Generously Donated By

Richard A. Freedman
Trust

Albuquerque / Bernalillo County
Library

Withdrawn/ABCL

D1095488

It was far out in a cotton field, split by lightning, decaying, collapsing, not so much a house as a memory of one.

I made no effort to console Porter Lee

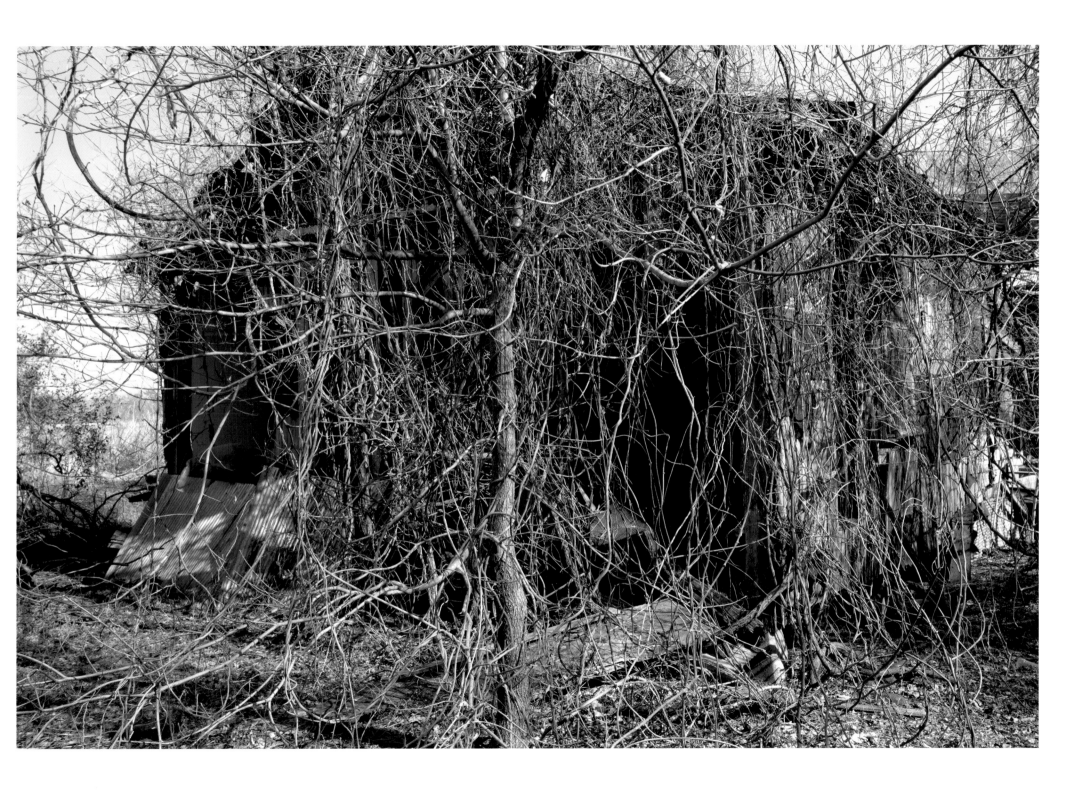

when she blurted out that as a child

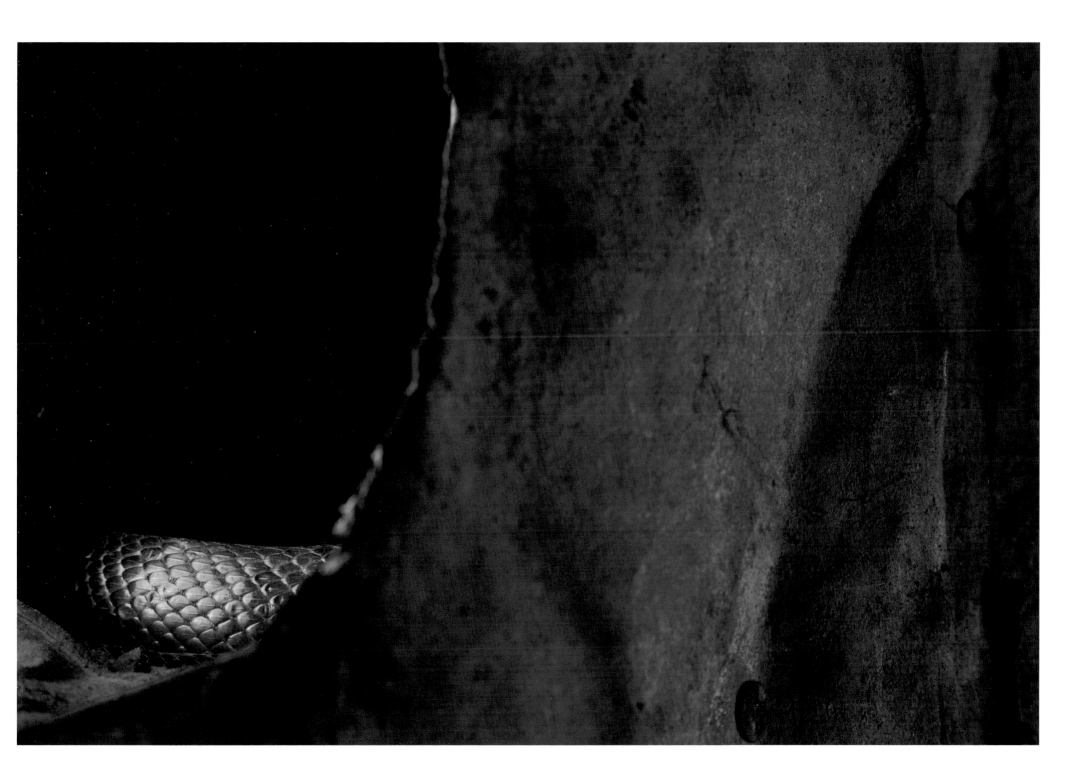

she was sometimes so hungry

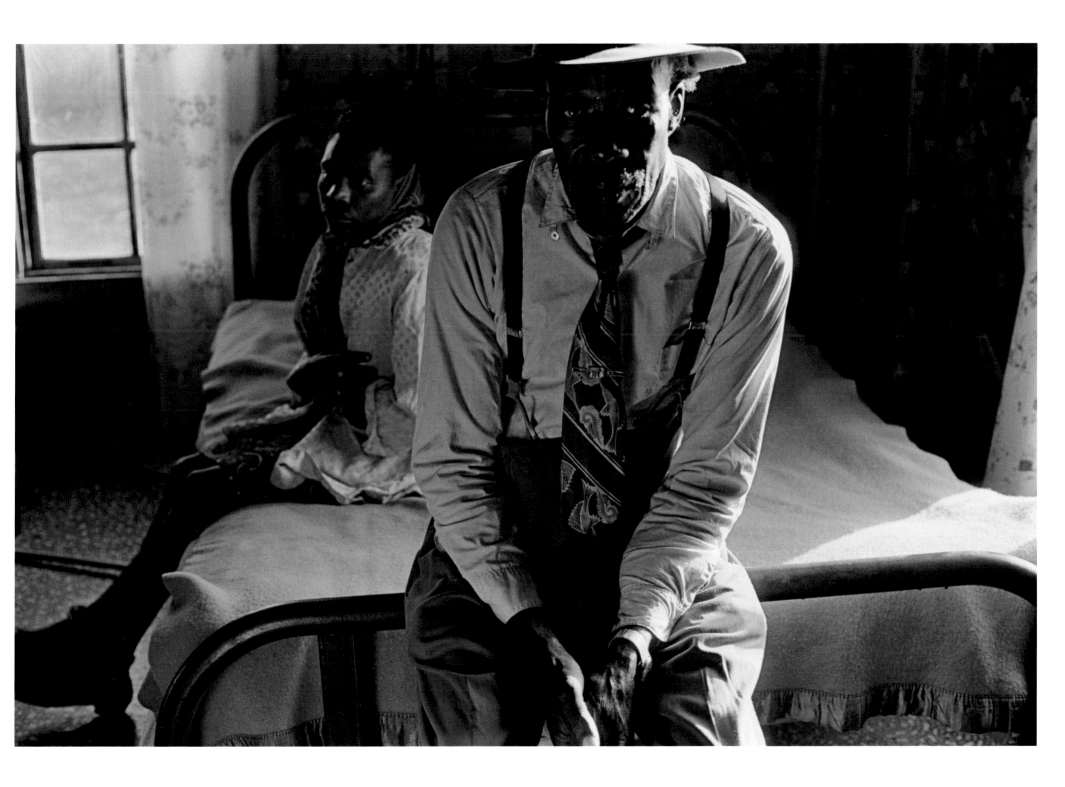

she'd scrape flour from the inside of barrels with a spoon.

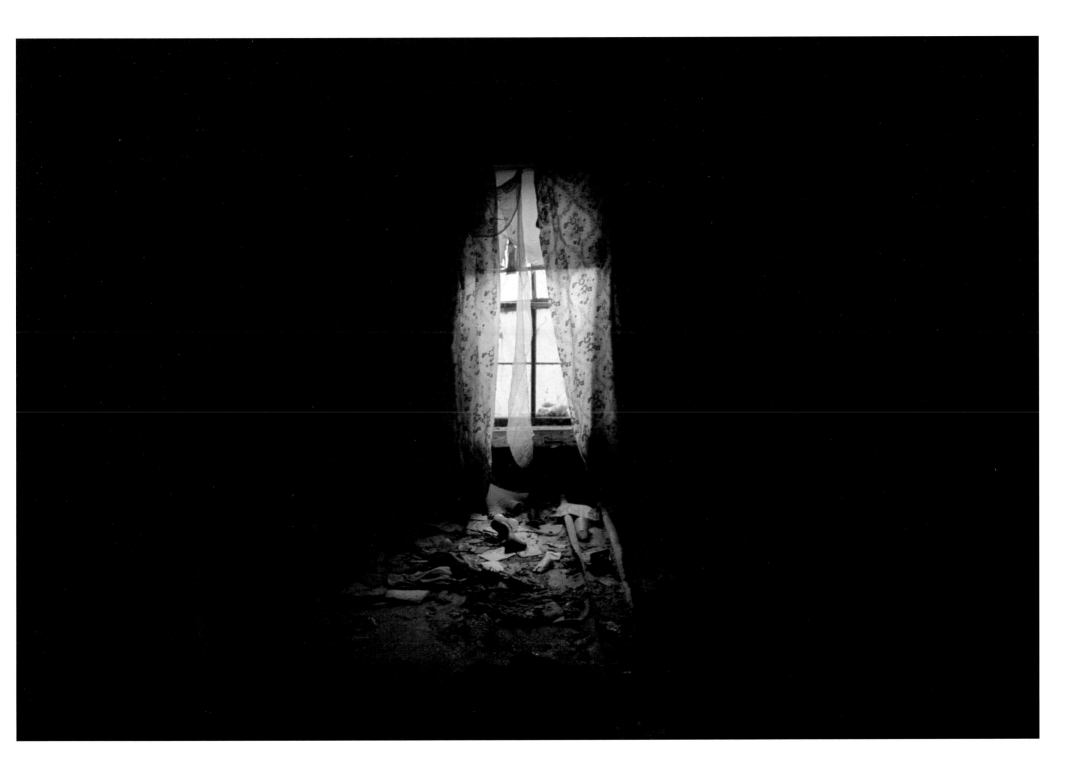

# Red Ball of a Sun Slipping Down

Eugene Richards

MANY VOICES PRESS

3907504766493

I wanted to hold her tight when she told me Mr. Will had been

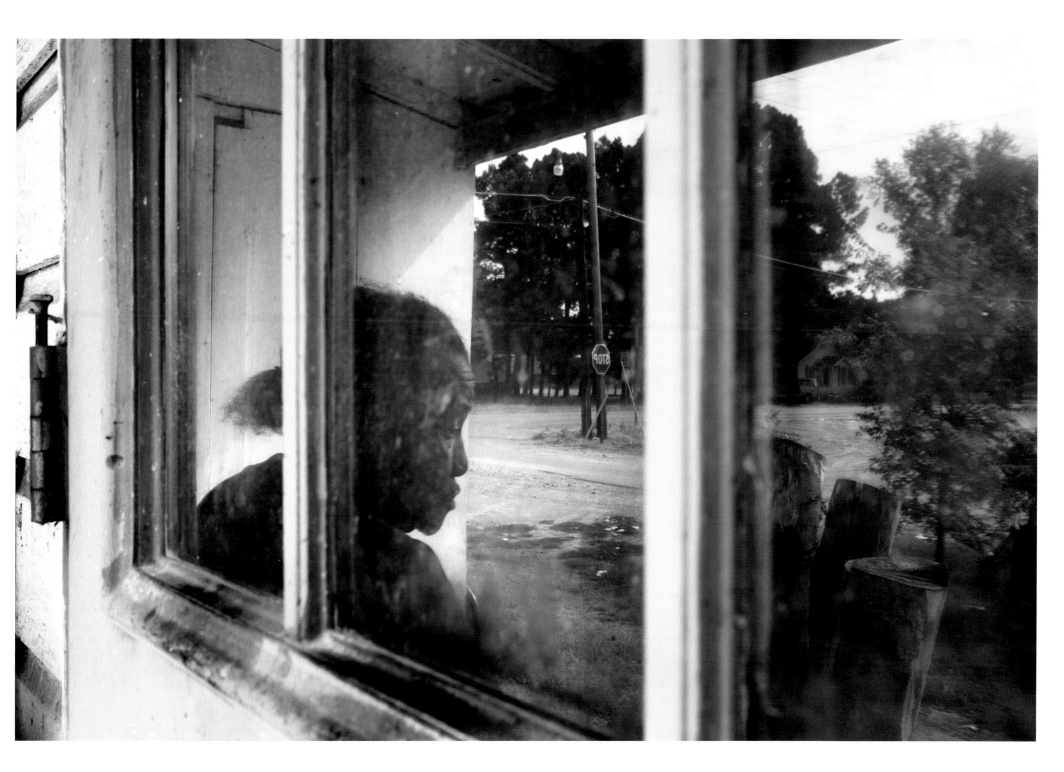

bleeding in the mouth all night long,

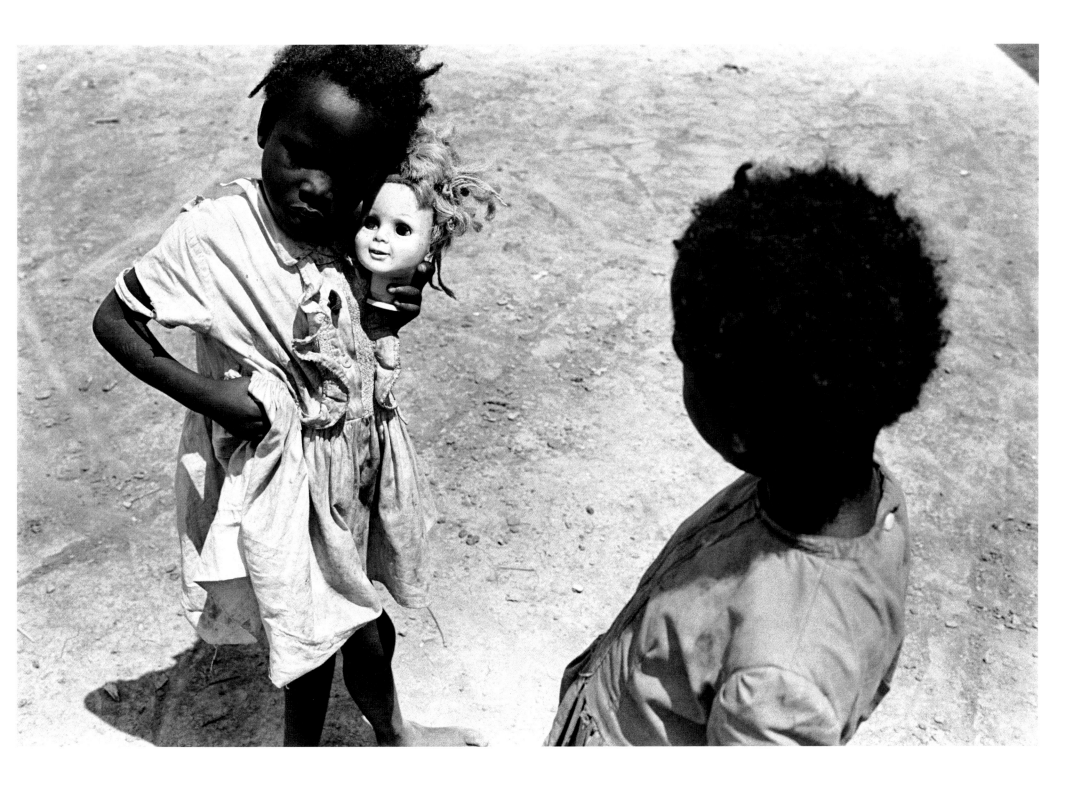

and her own heart was worrying her, too.

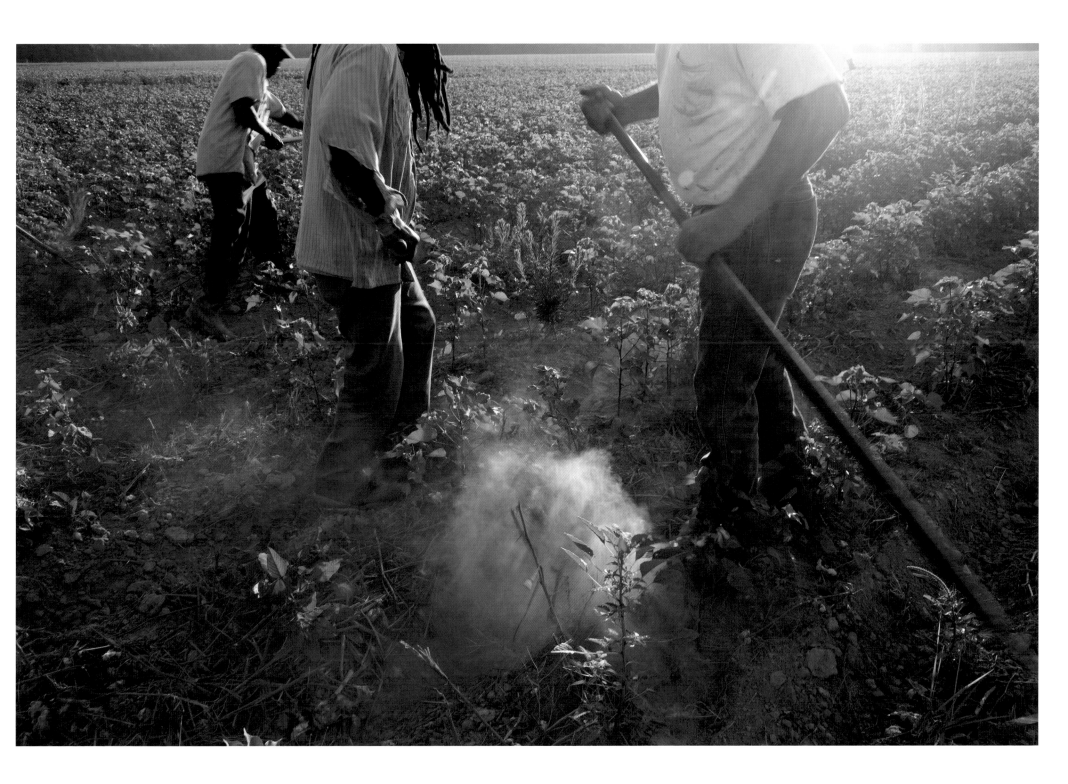

But I didn't.

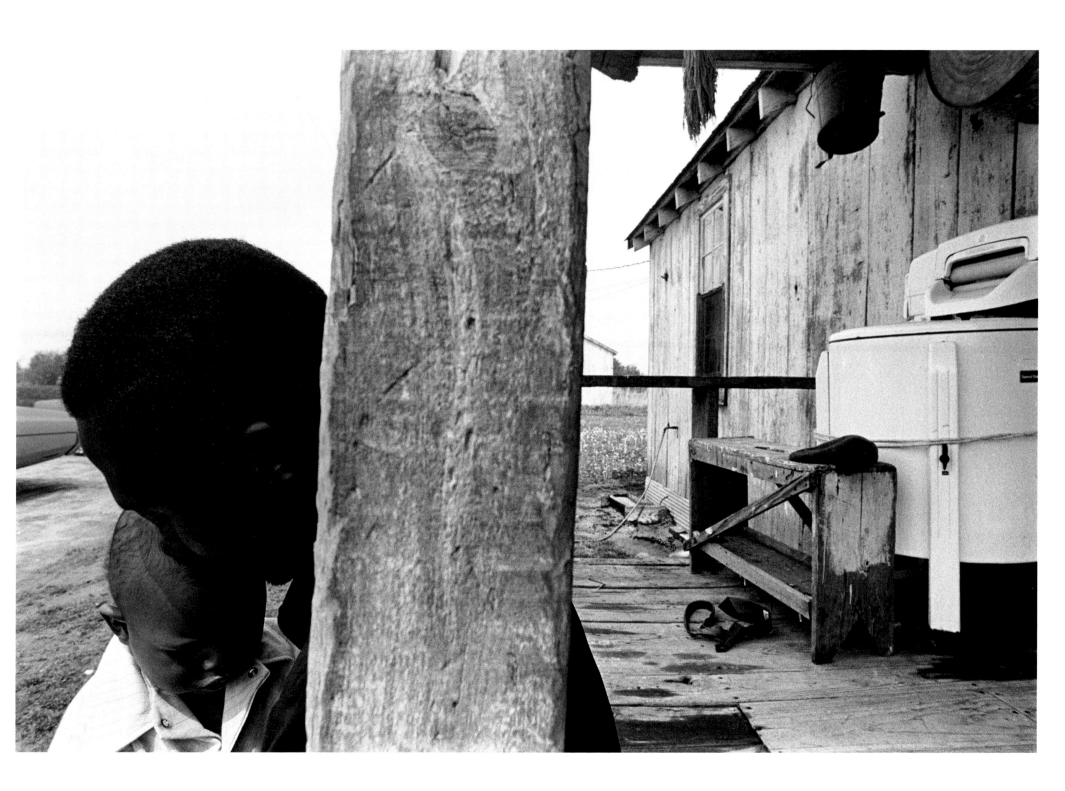

Ever since Porter Lee let me into her house

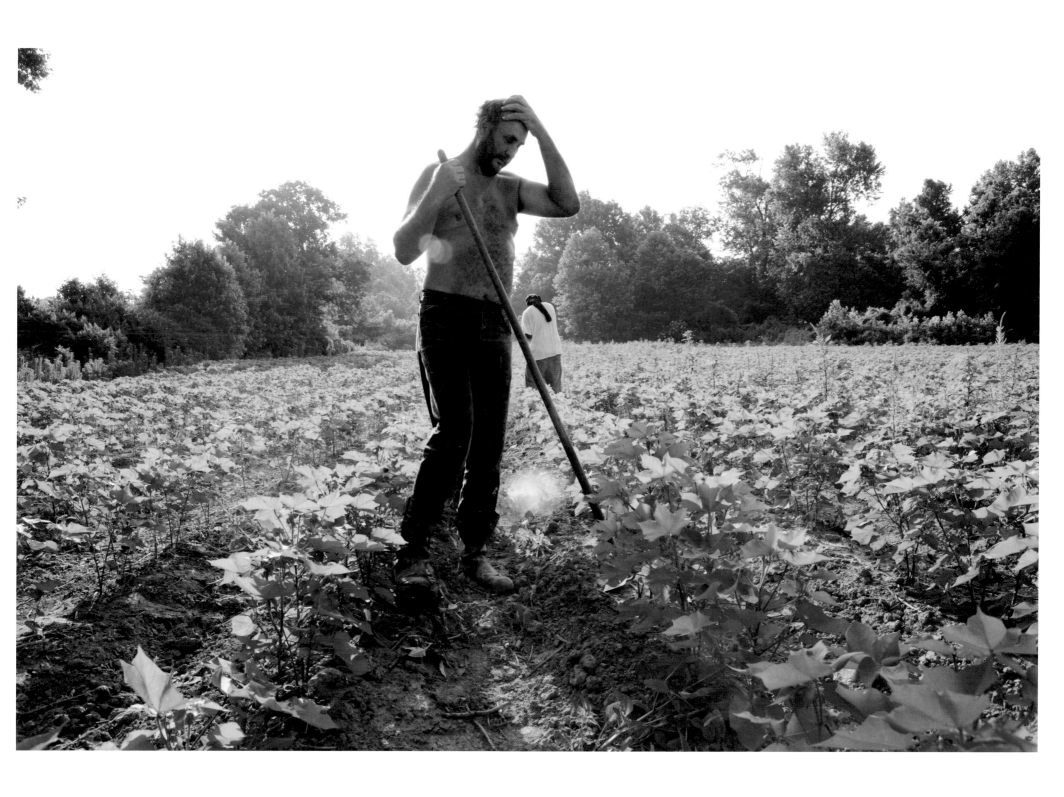

there had been this distance

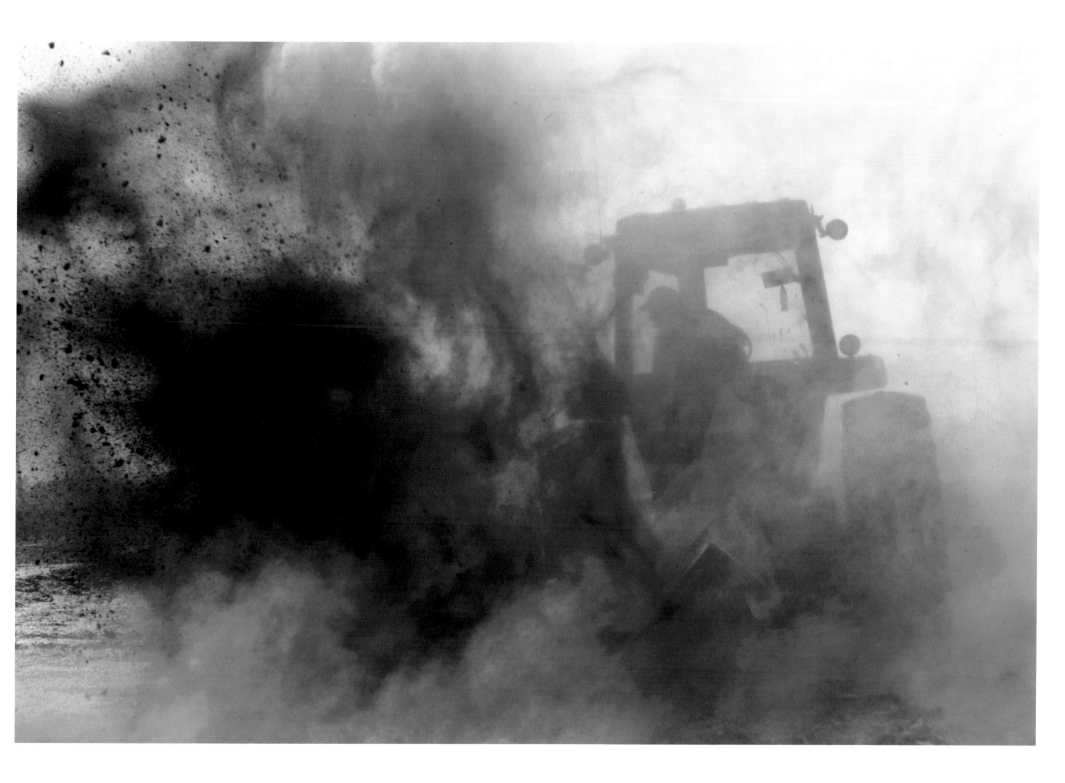

or tension between us.

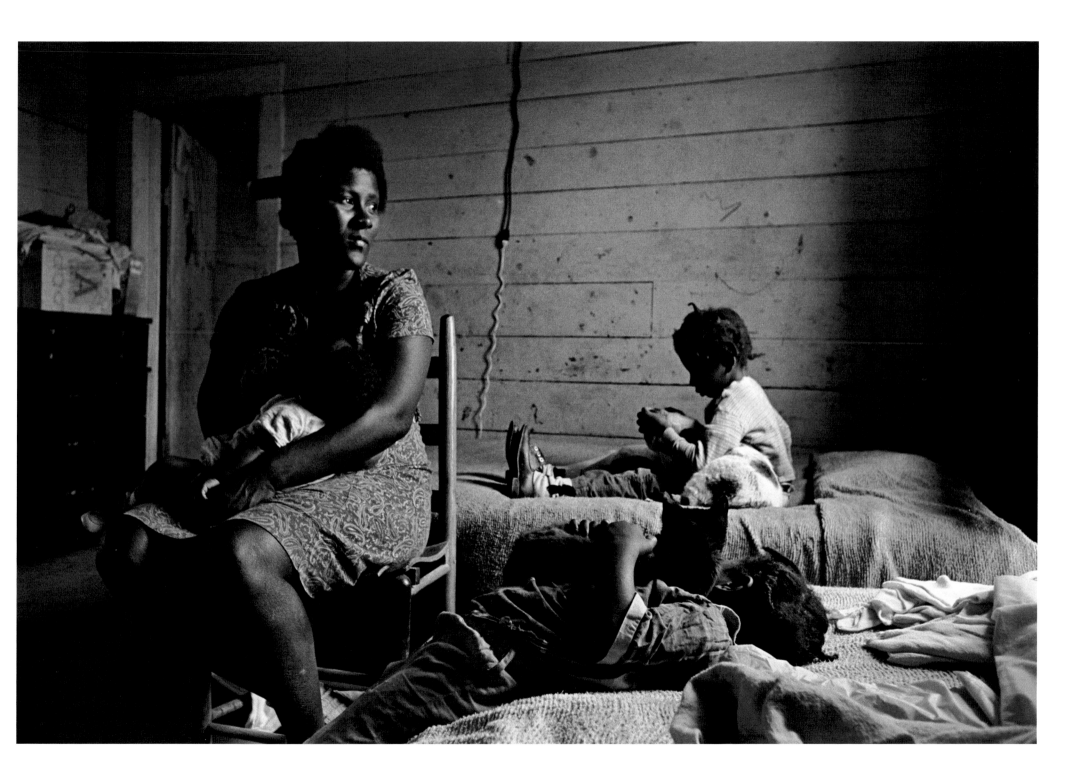

She never looked me straight in the face when we talked.

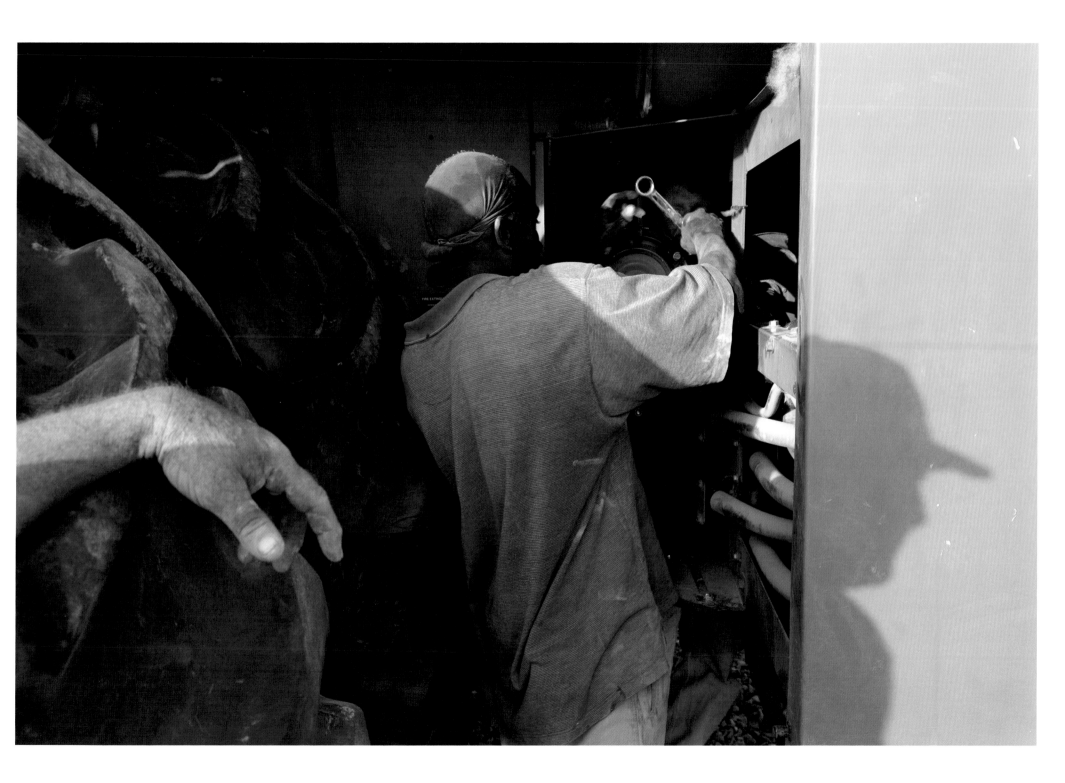

And if we weren't talking she ignored me,

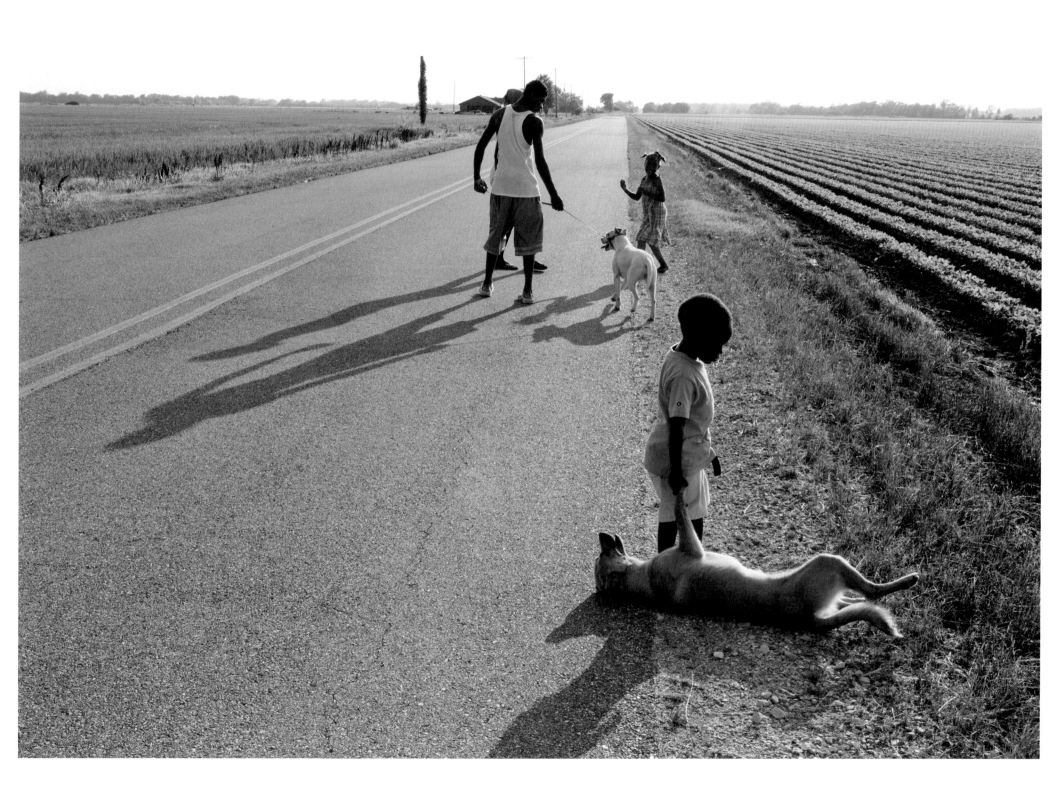

except to shake her head when she thought I was taking

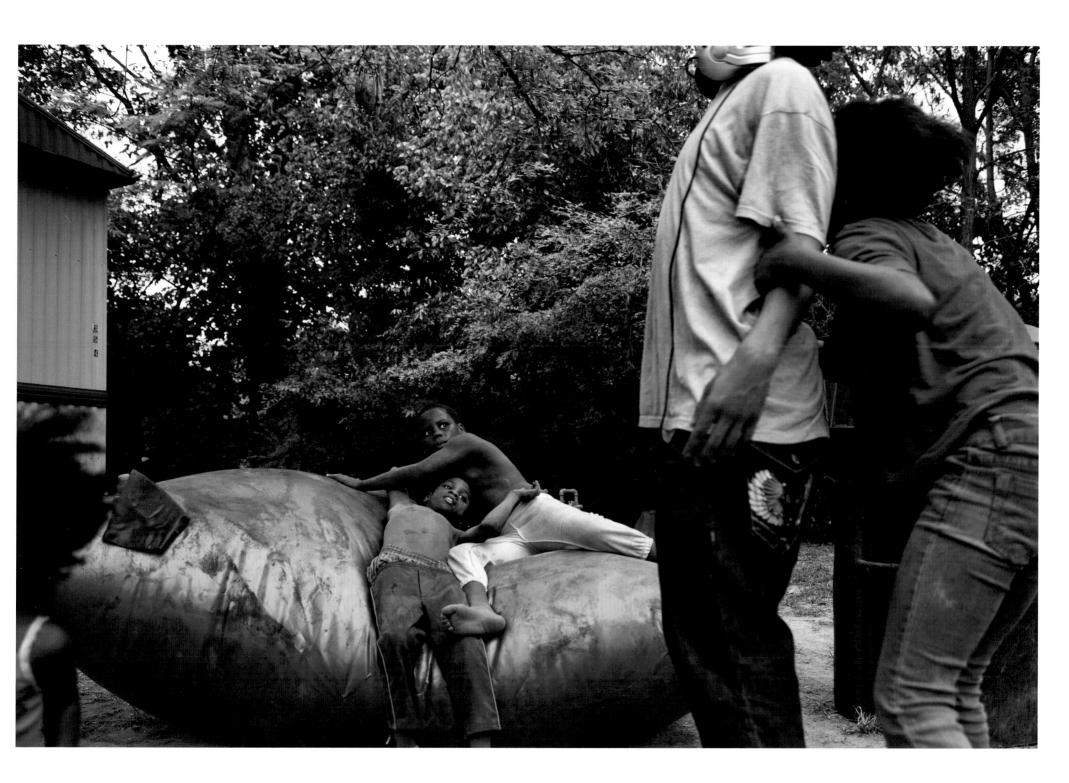

too many pictures of her grandkids.

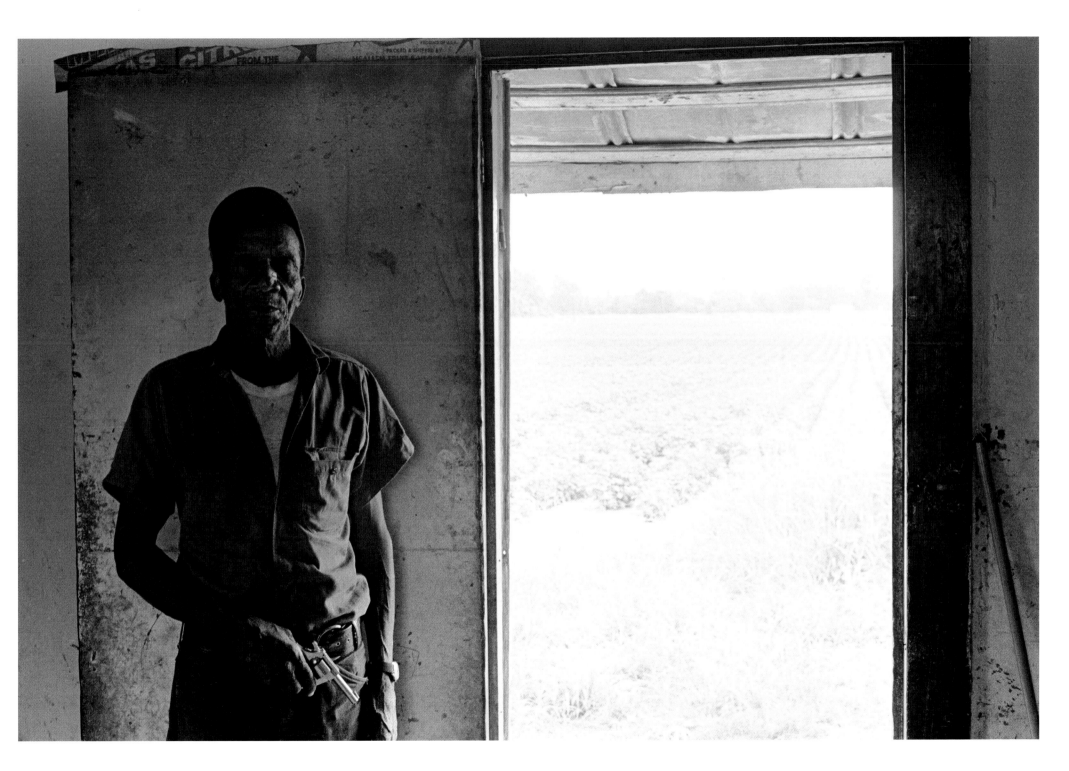

Lots of times I went back to my motel room

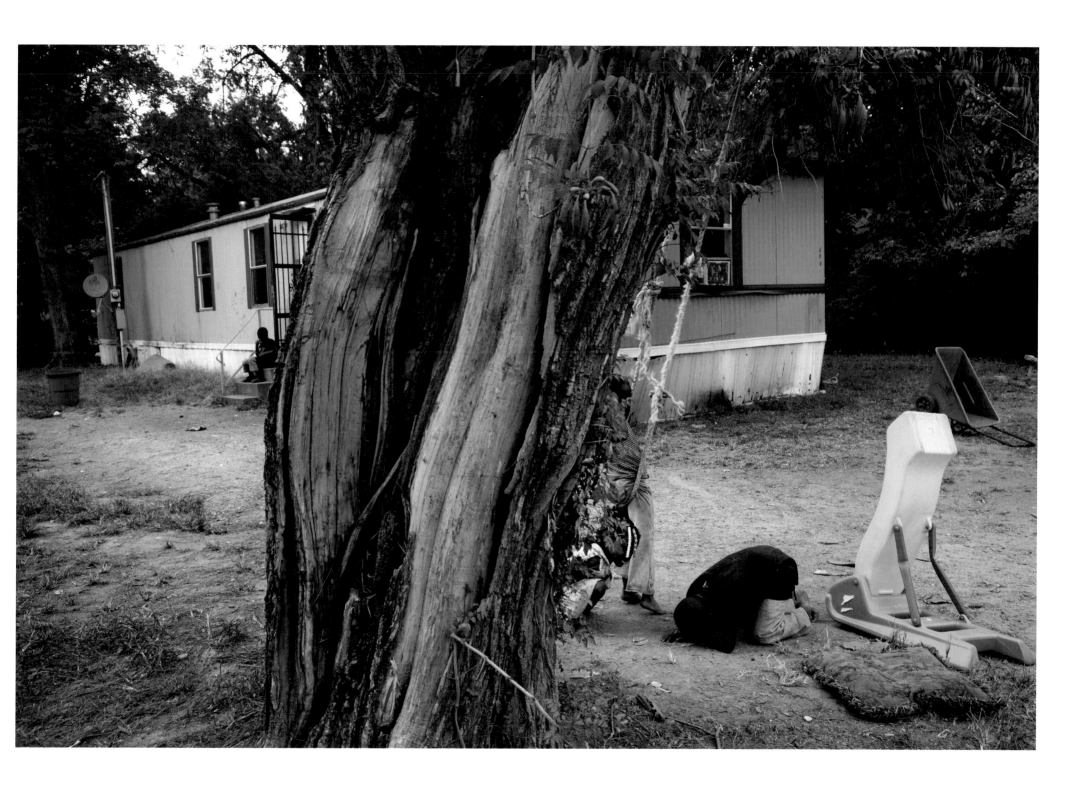

all headachy and depressed,

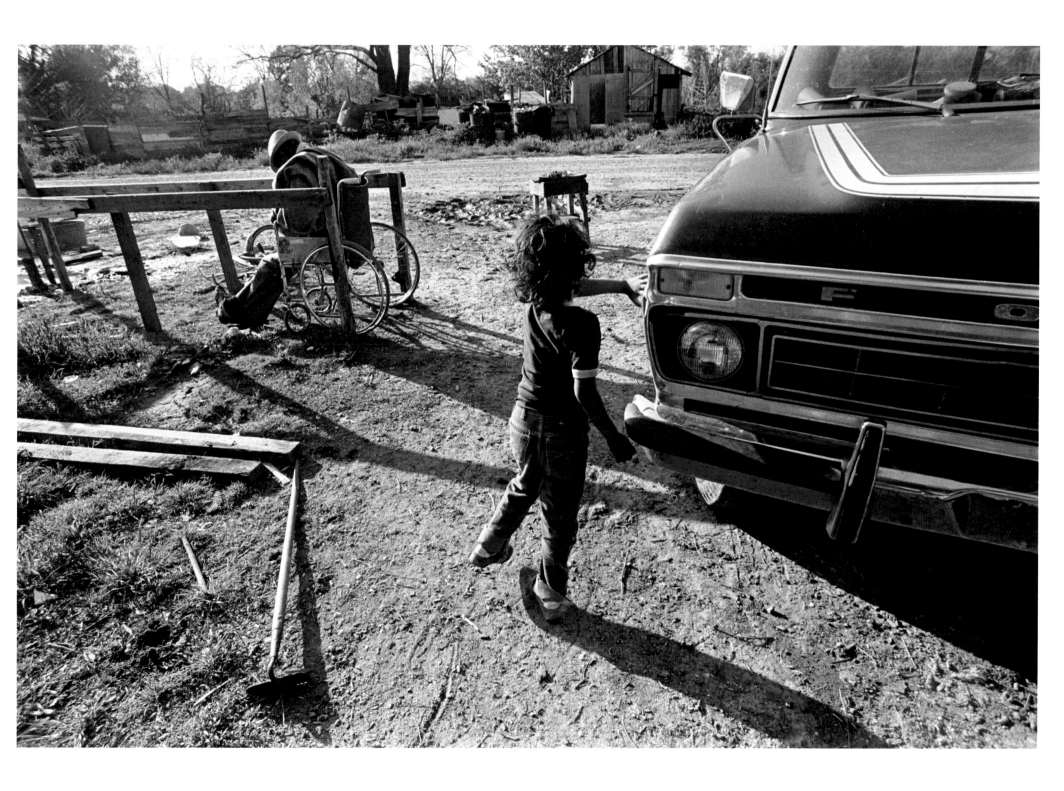

feeling that I'd been intruding.

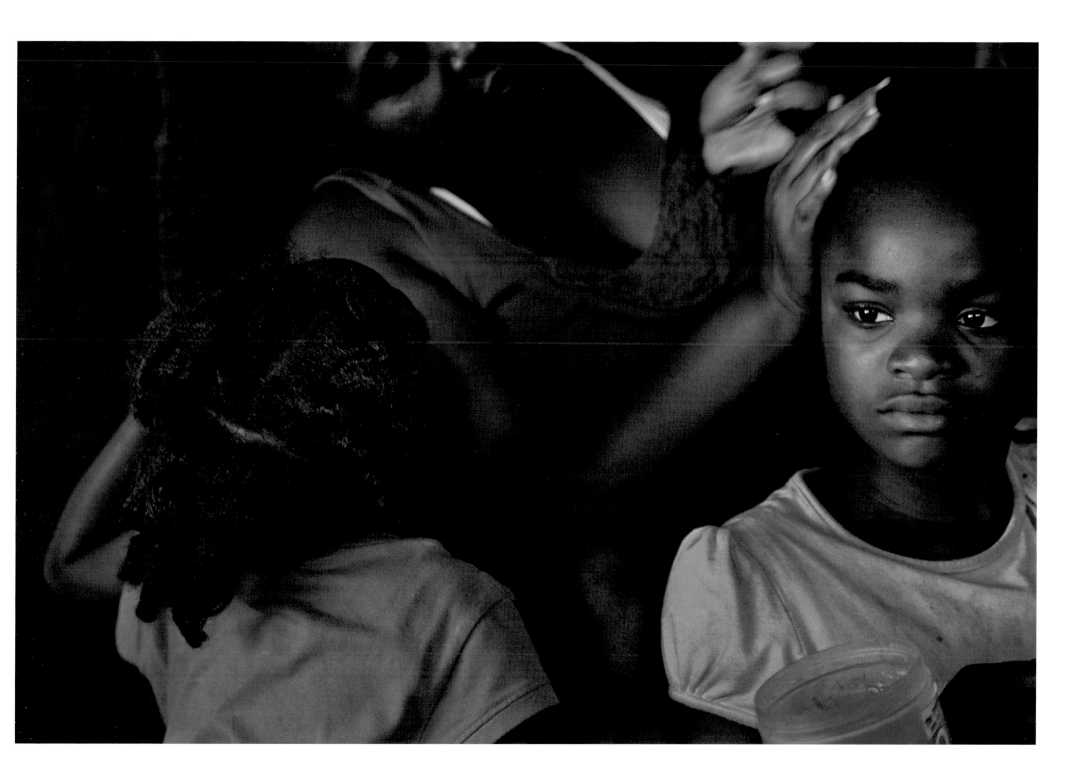

Then tonight I see a look of panic on her face when

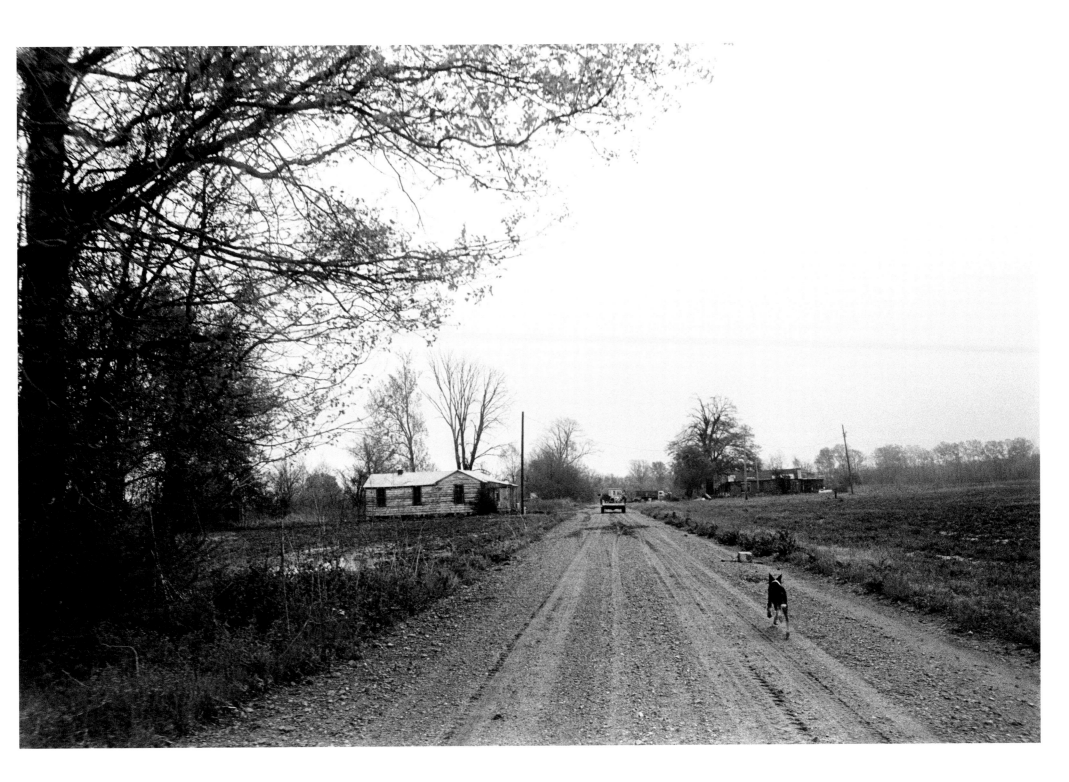

I tell her it's time for me to leave the delta.

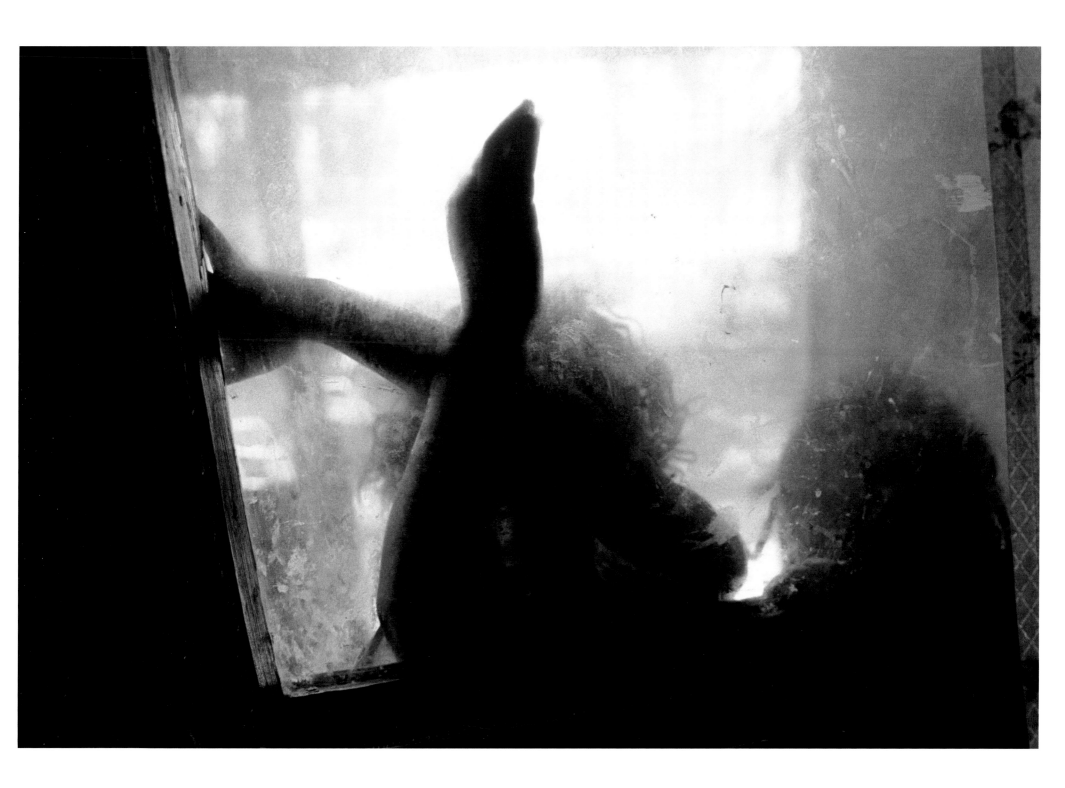

She presses her hand against her forehead

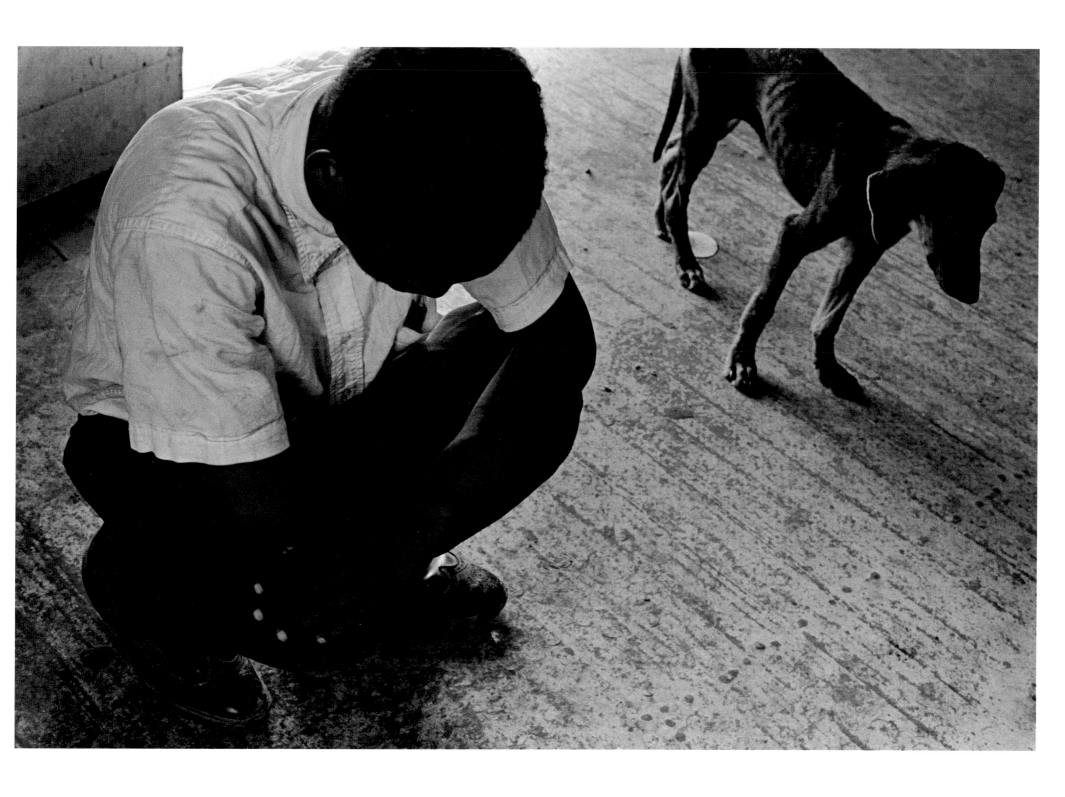

as if to extinguish a pain there,

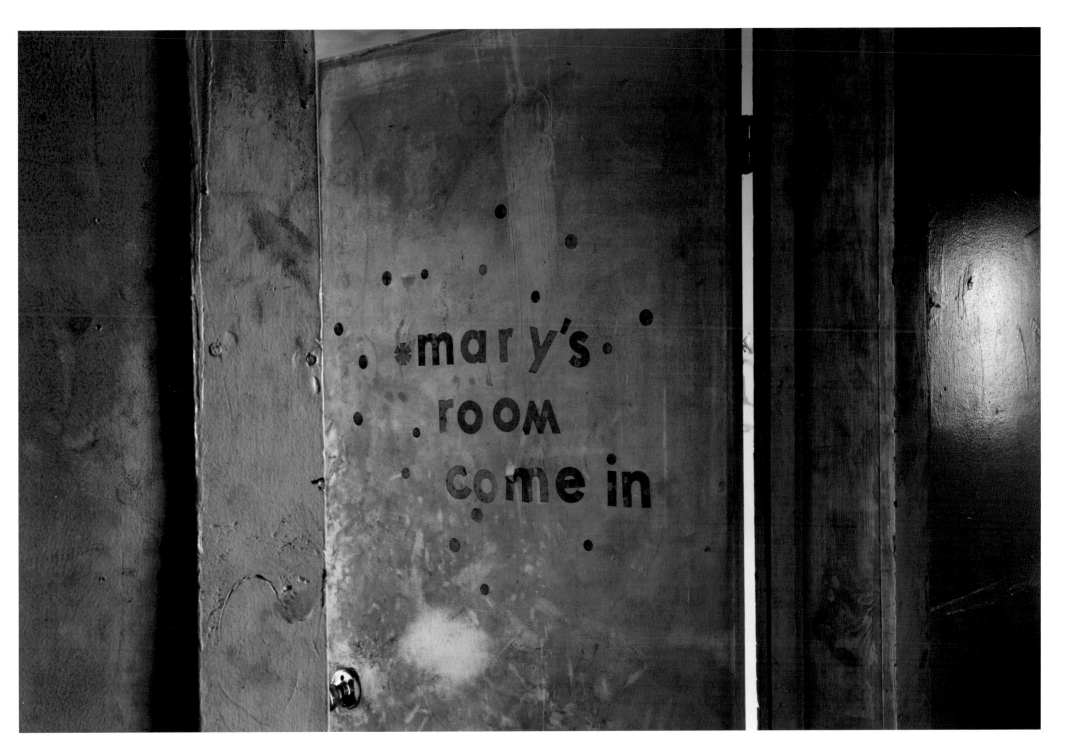

and pushes past me out through the kitchen.

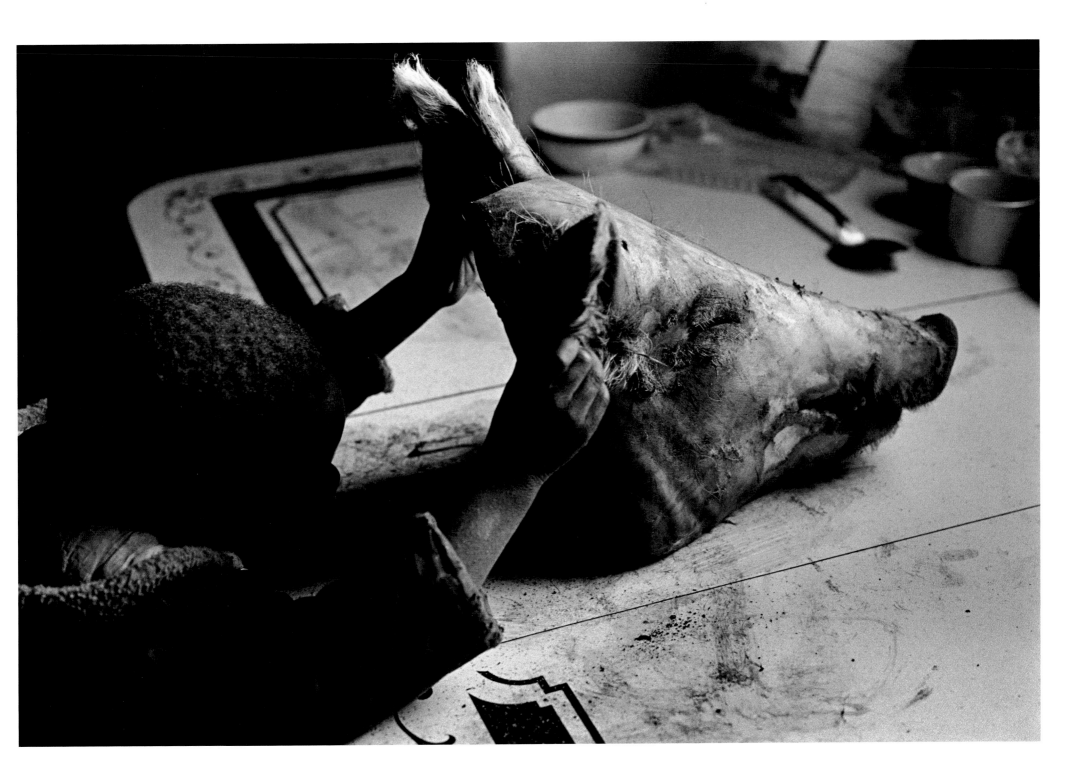

Porter Lee calls her granddaughters up onto the broken and uneven stoop.

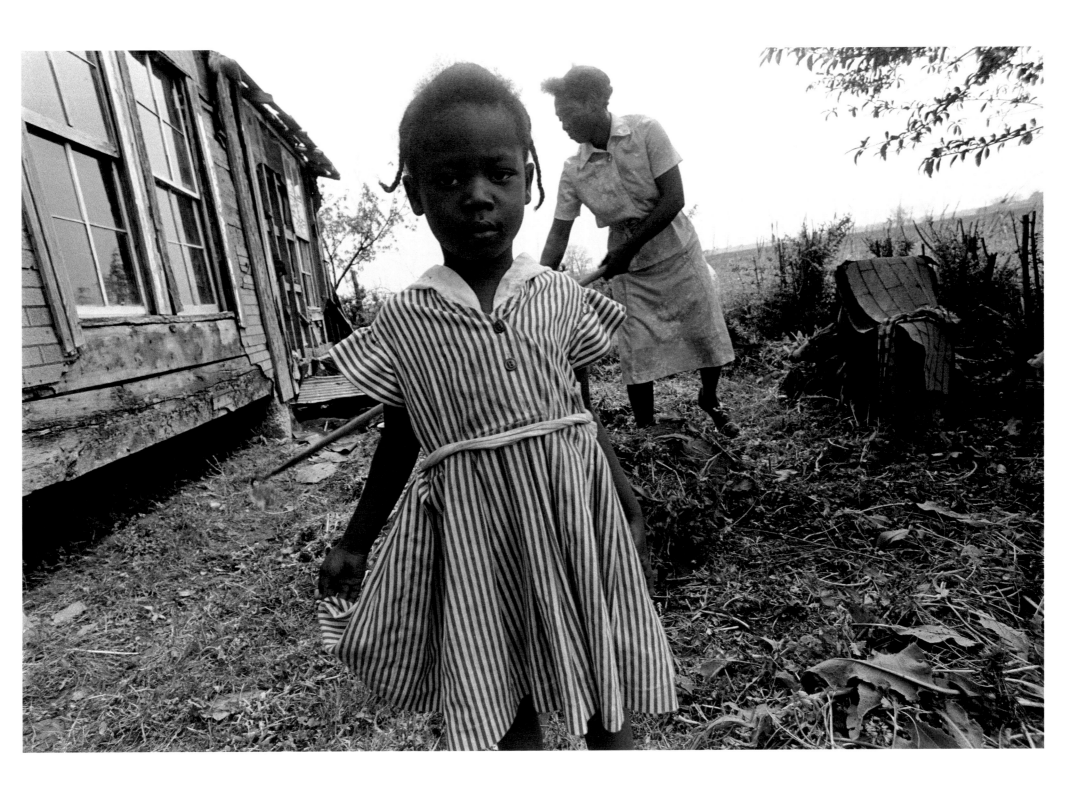

Cilla sits in her lap, Sandra in mine,

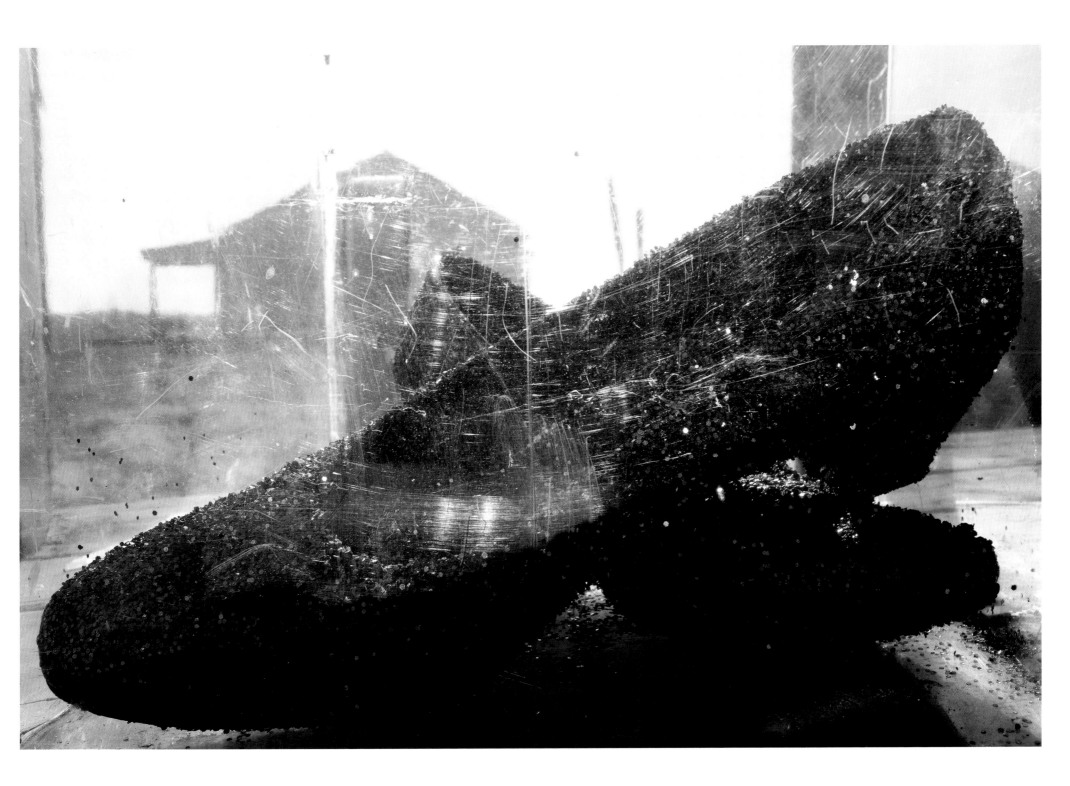

and we watch the sun slip down,

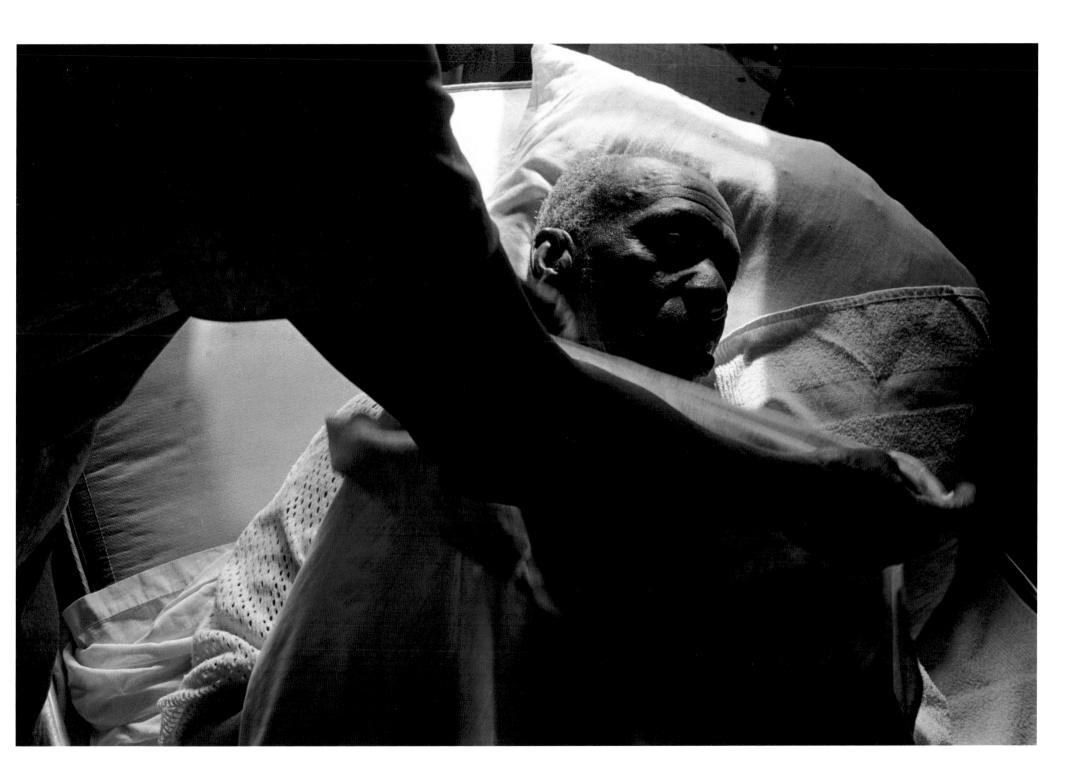

the red stain settling over everything.

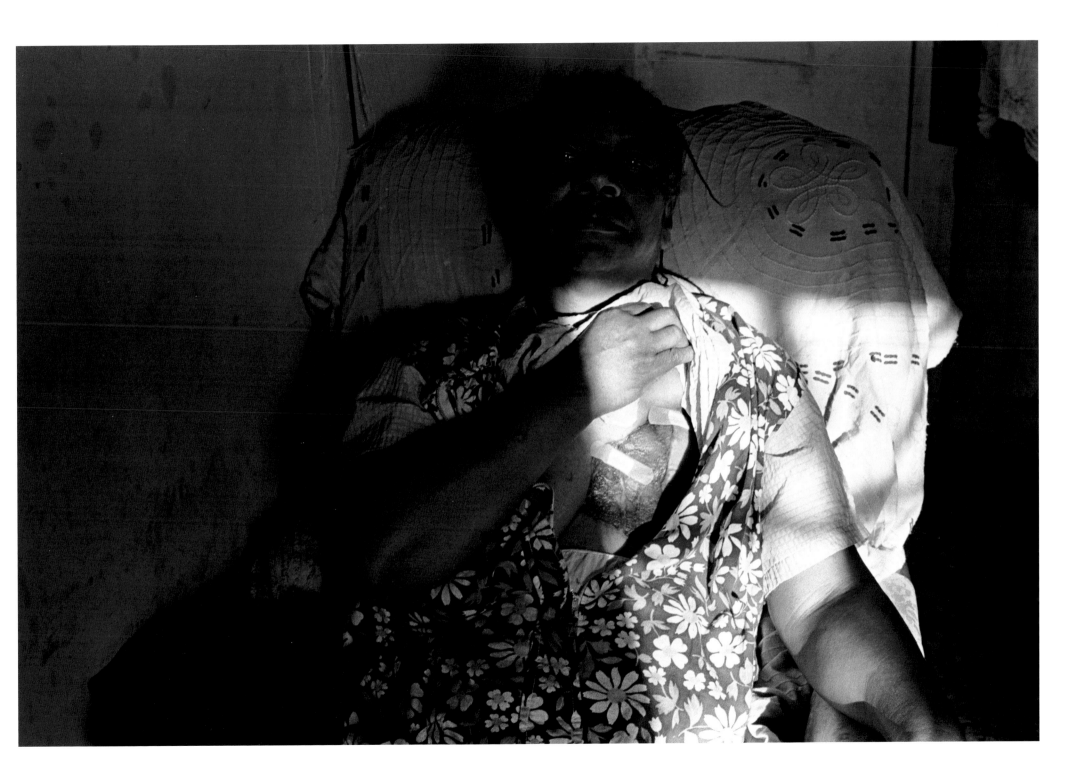

Shadows lengthen, and the castoff box spring, junked car, and

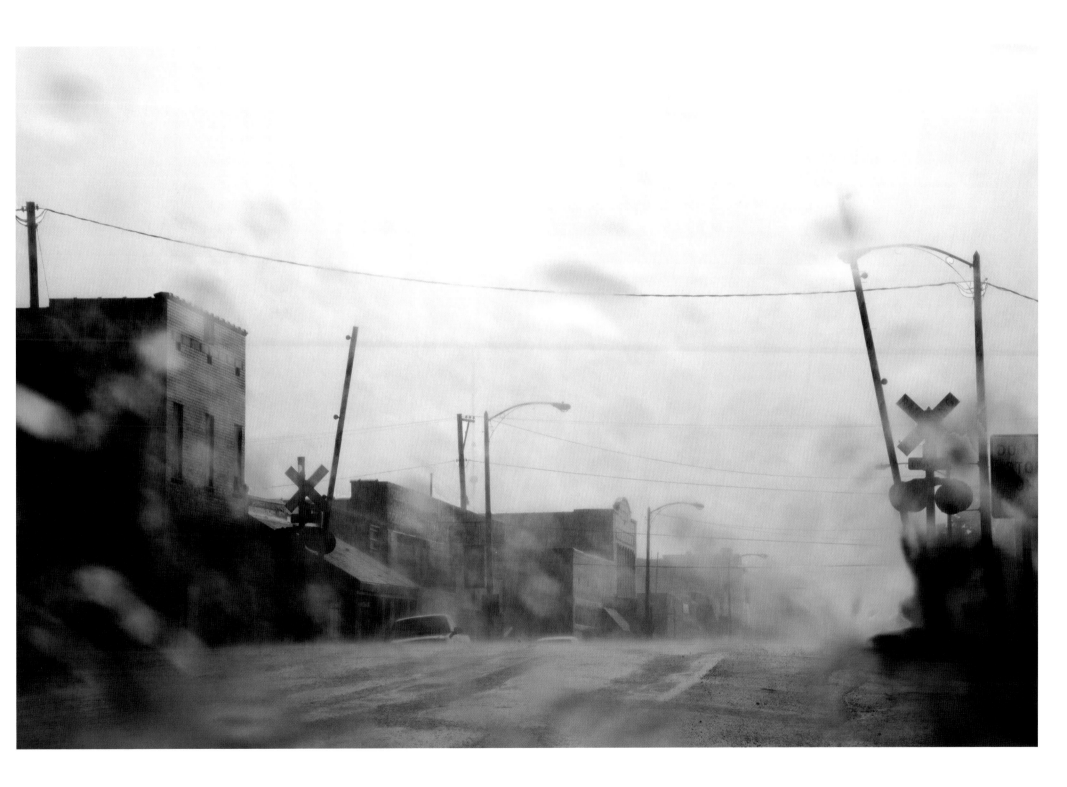

children's headless, wheelless playthings melt together under the trees.

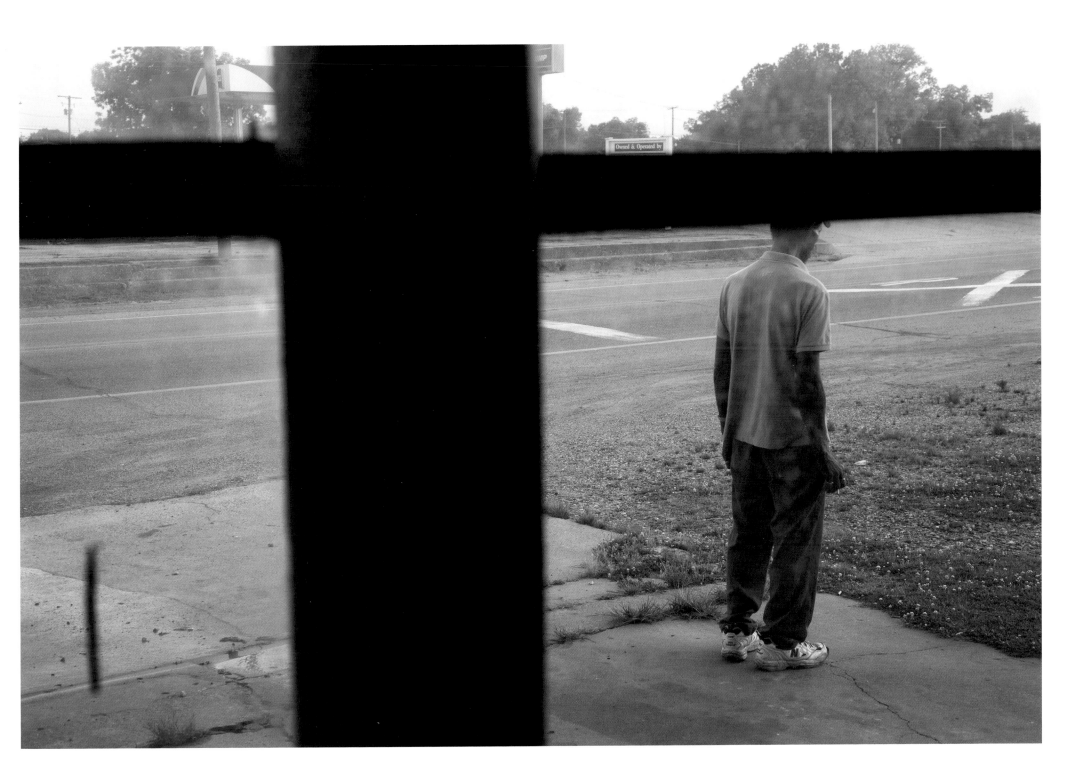

The sun drops until it's at eye level and blinds us.

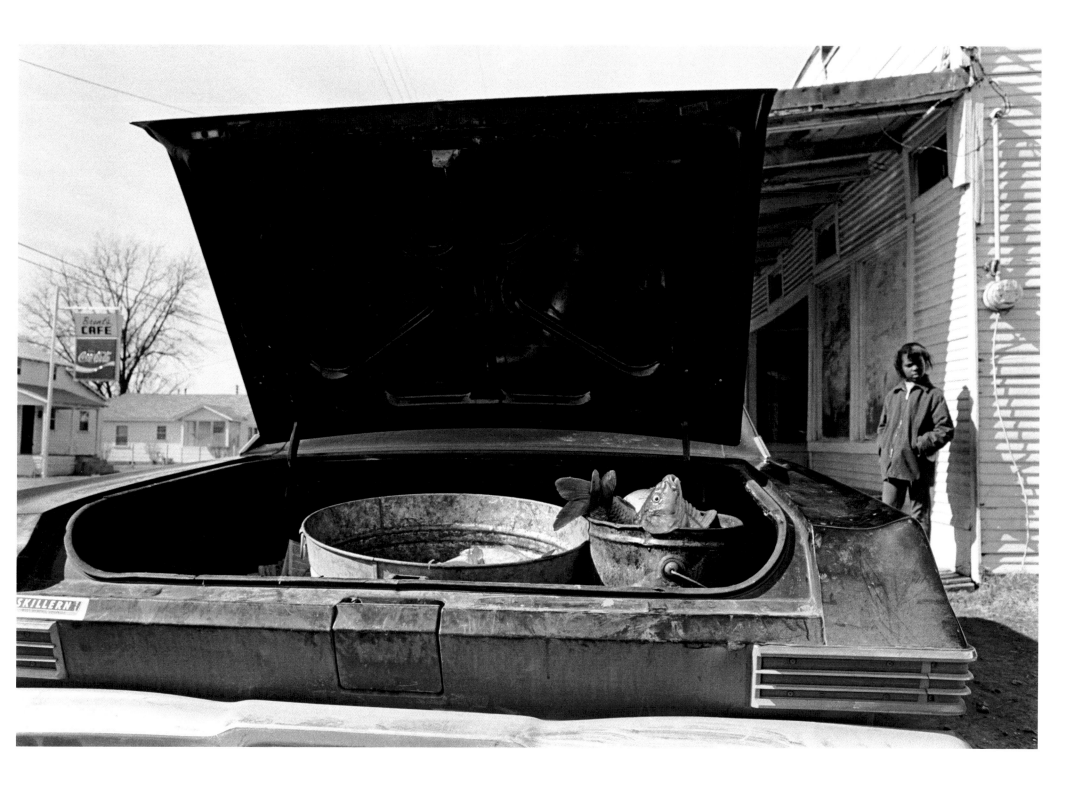

I look down at my feet, then behind me.

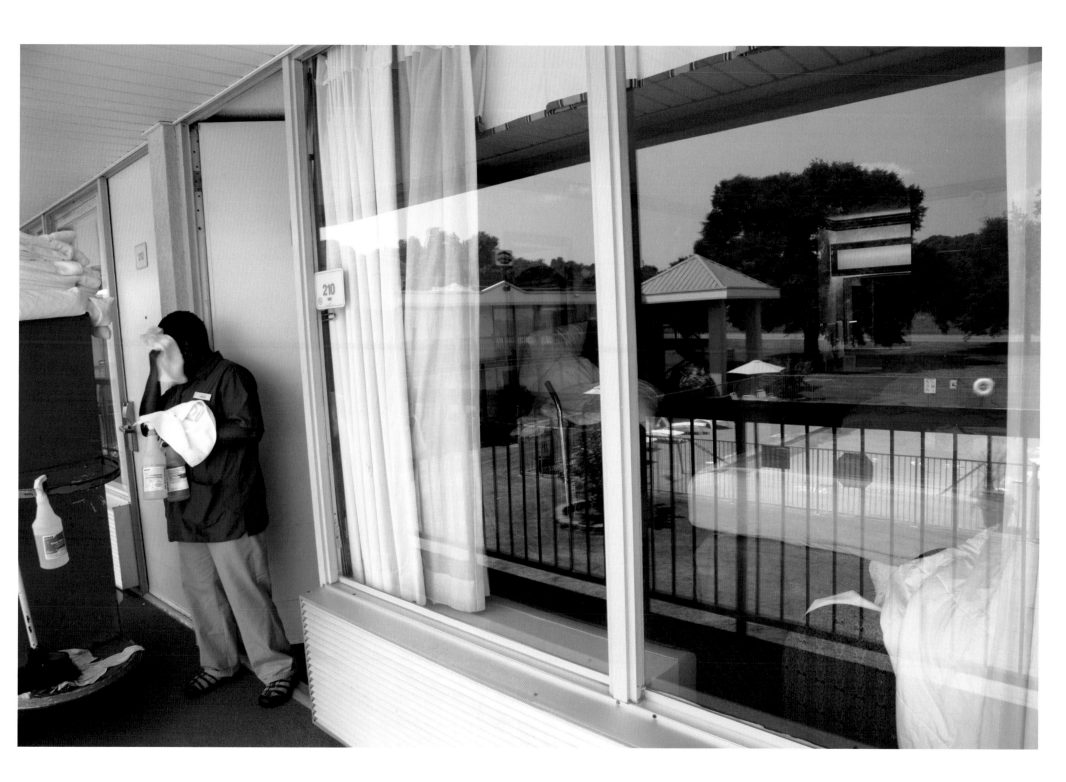

Having crawled from the bed into his wheelchair, Mr. Will is sitting there smiling.

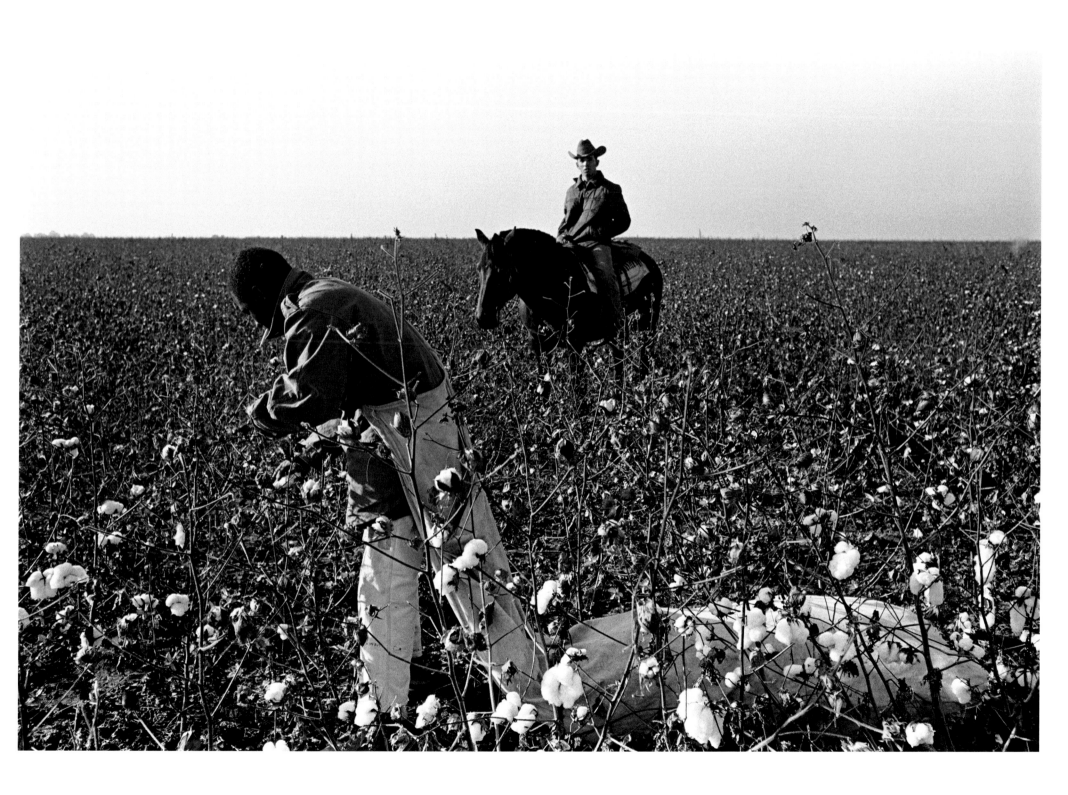

I nod and he lowers his head into the clean, white handkerchief on his knees.

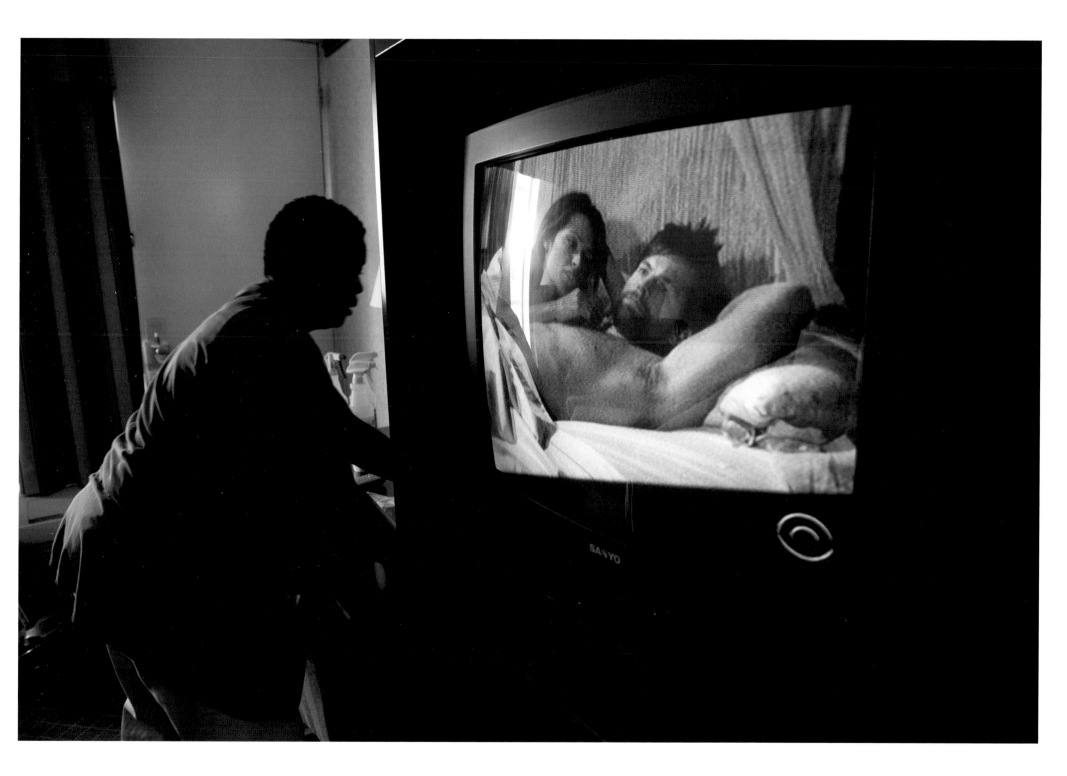

"What you'll do," Porter Lee says, "is forget us."

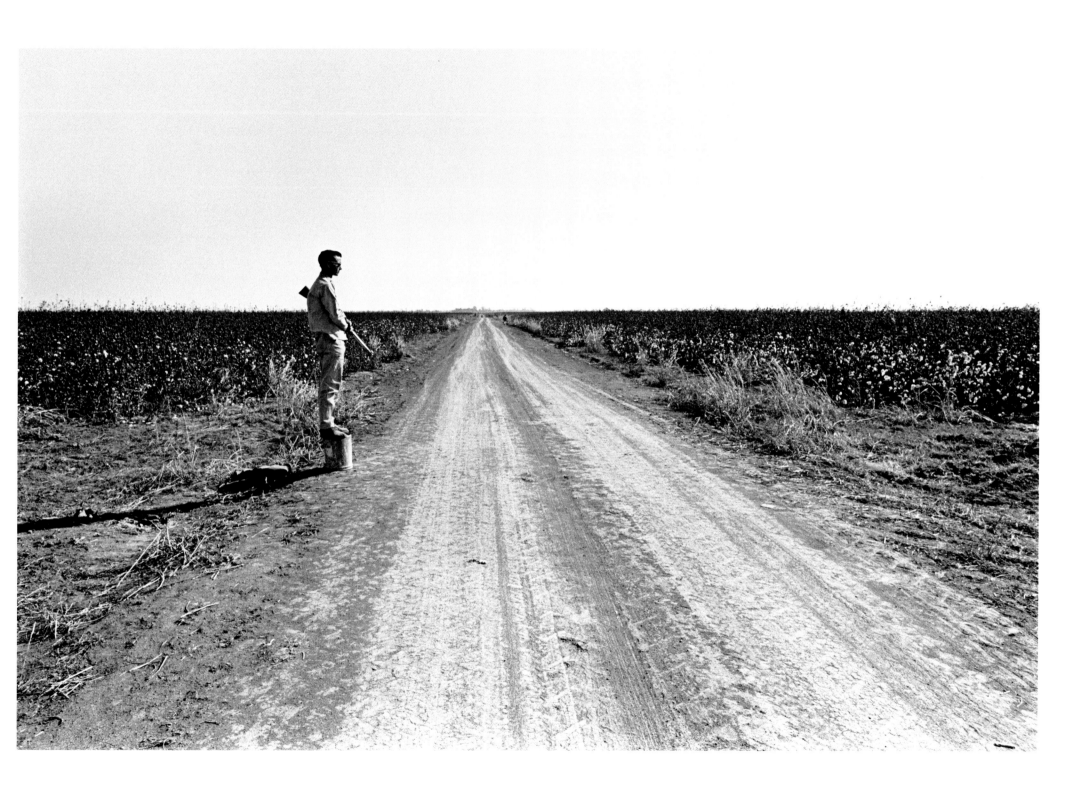

I wake bolt upright before dawn, hearing voices,

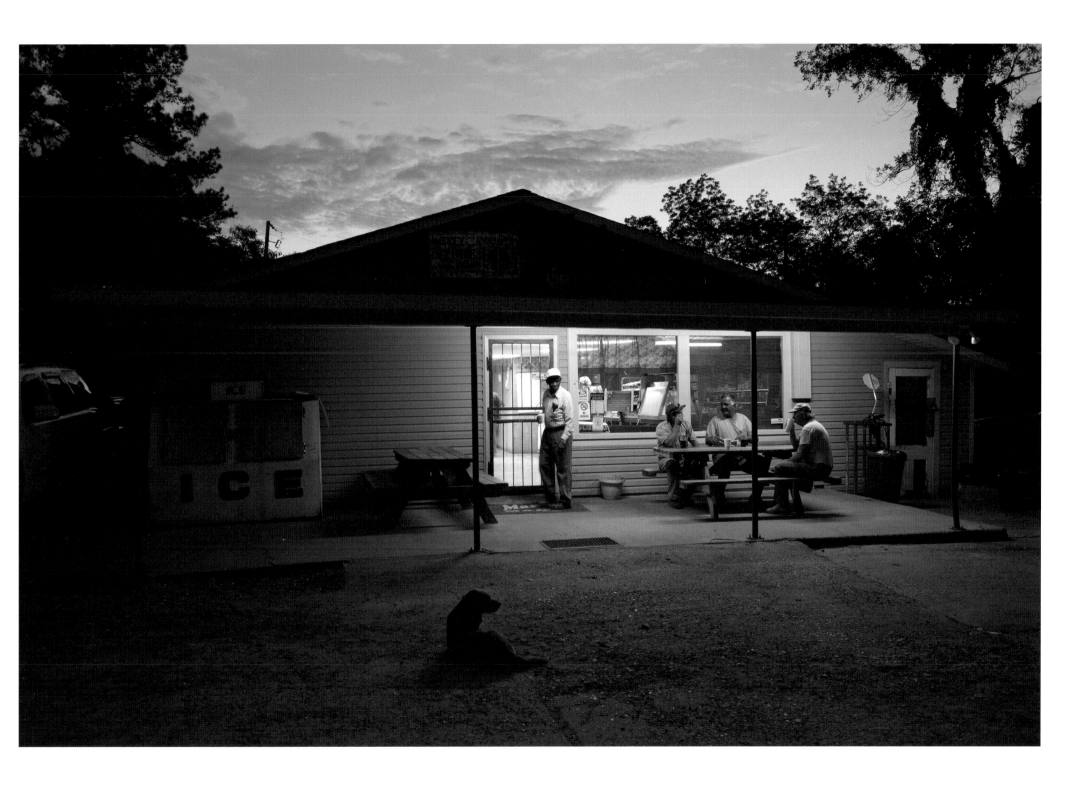

someone coughing close by, and fumble for the light switch.

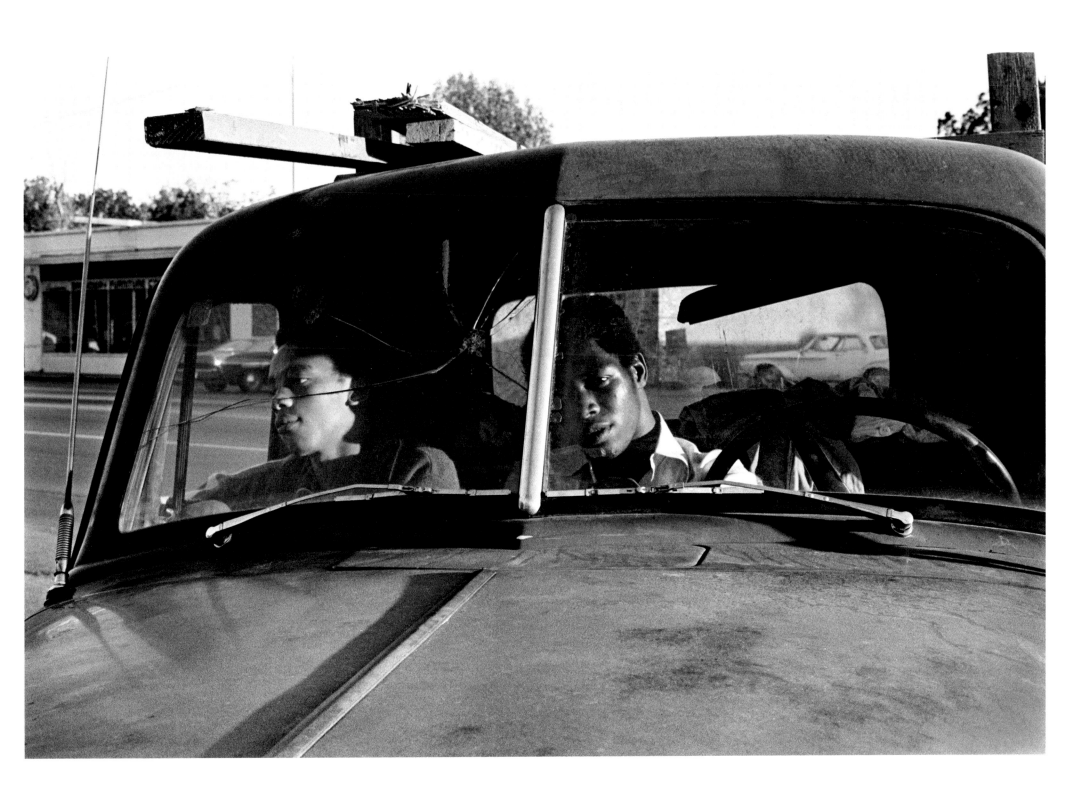

It takes a full minute for the buzzing, fluttering, fluorescent tube

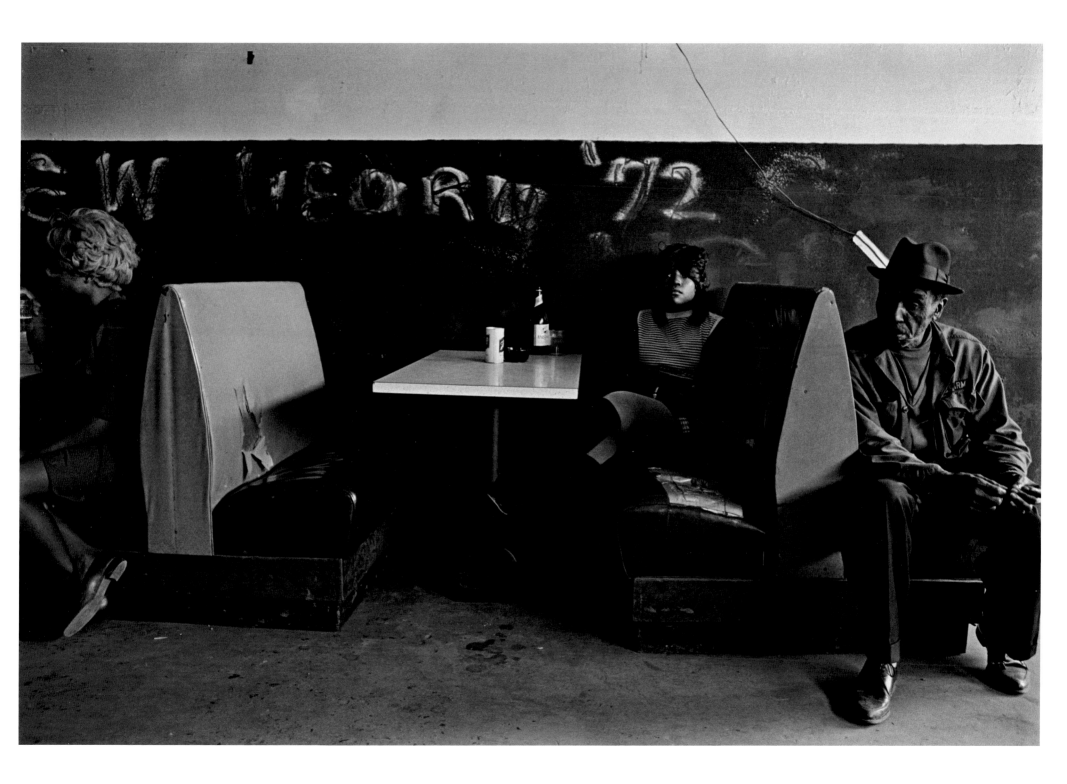

to come on, and a few minutes more for me

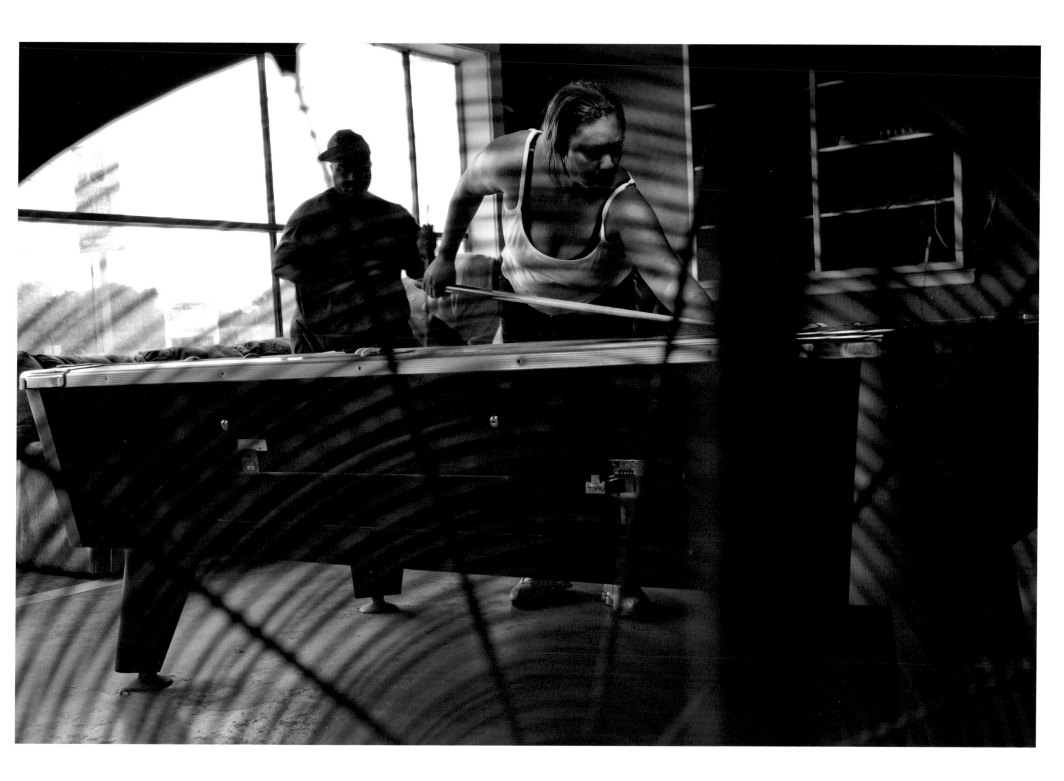

to be sure of just where I am,

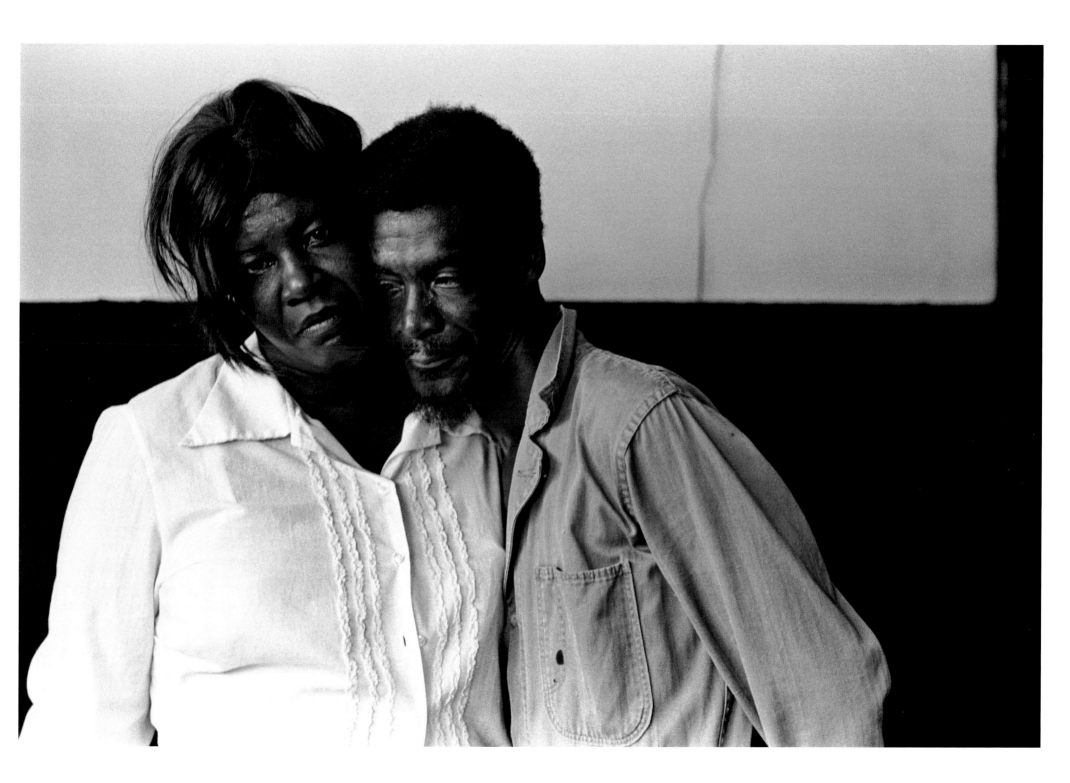

alone in a shoebox of a motel.

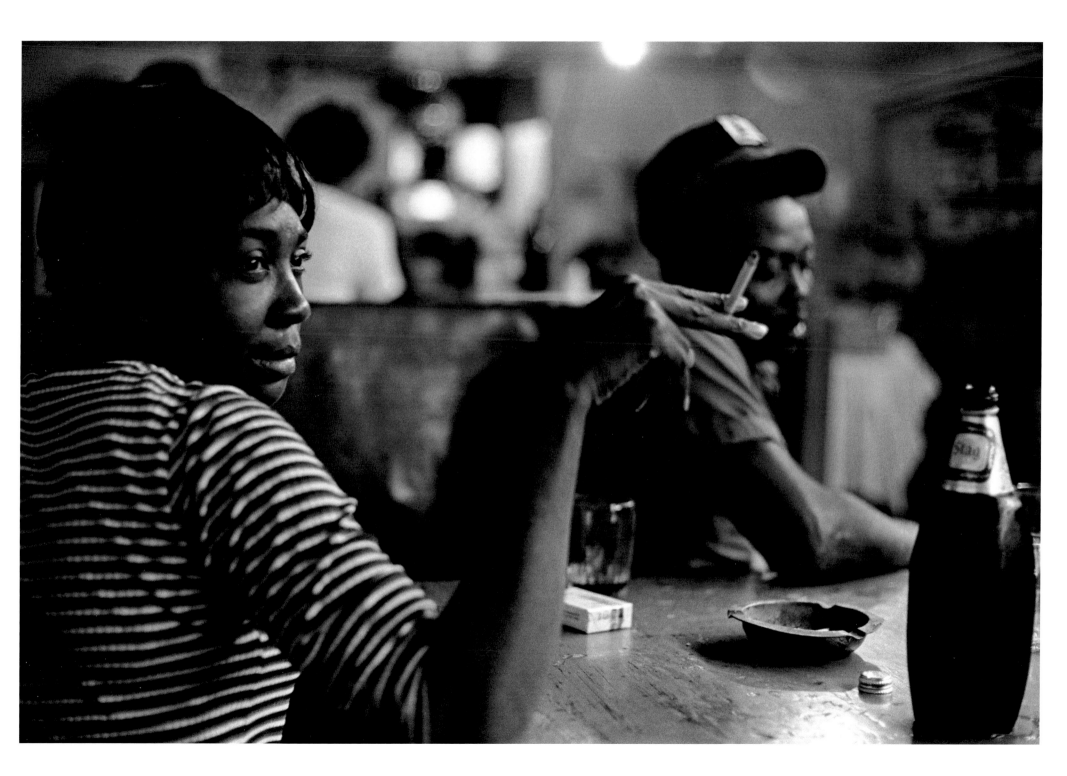

My eyes drift from the cameras and clothes dropped on the floor, to a snapshot of Janine,

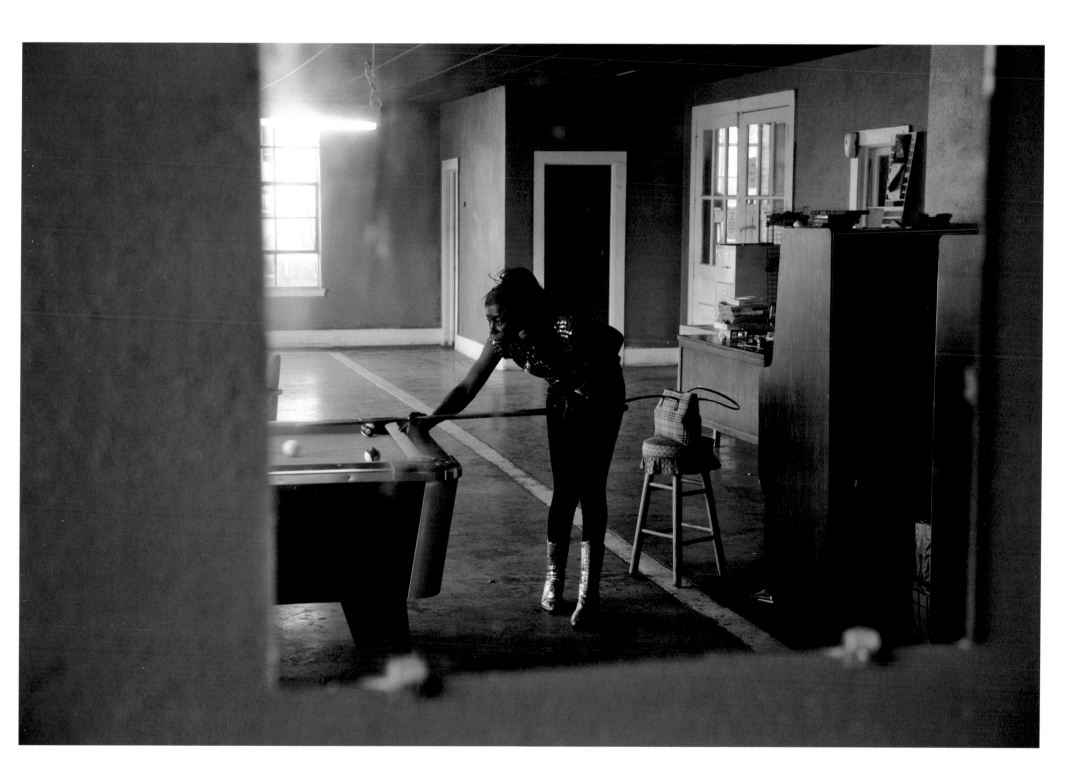

to the window and the phone booth out at the edge of the highway.

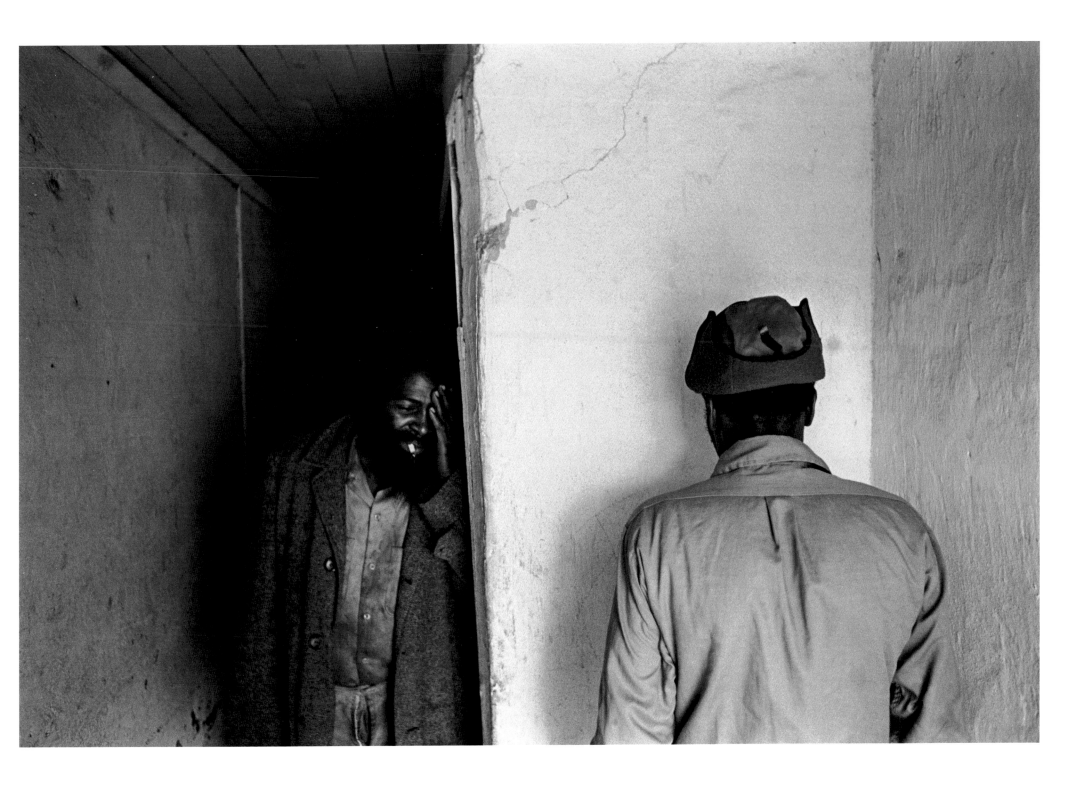

When I put my glasses on I see myself in the shaving mirror above the sink.

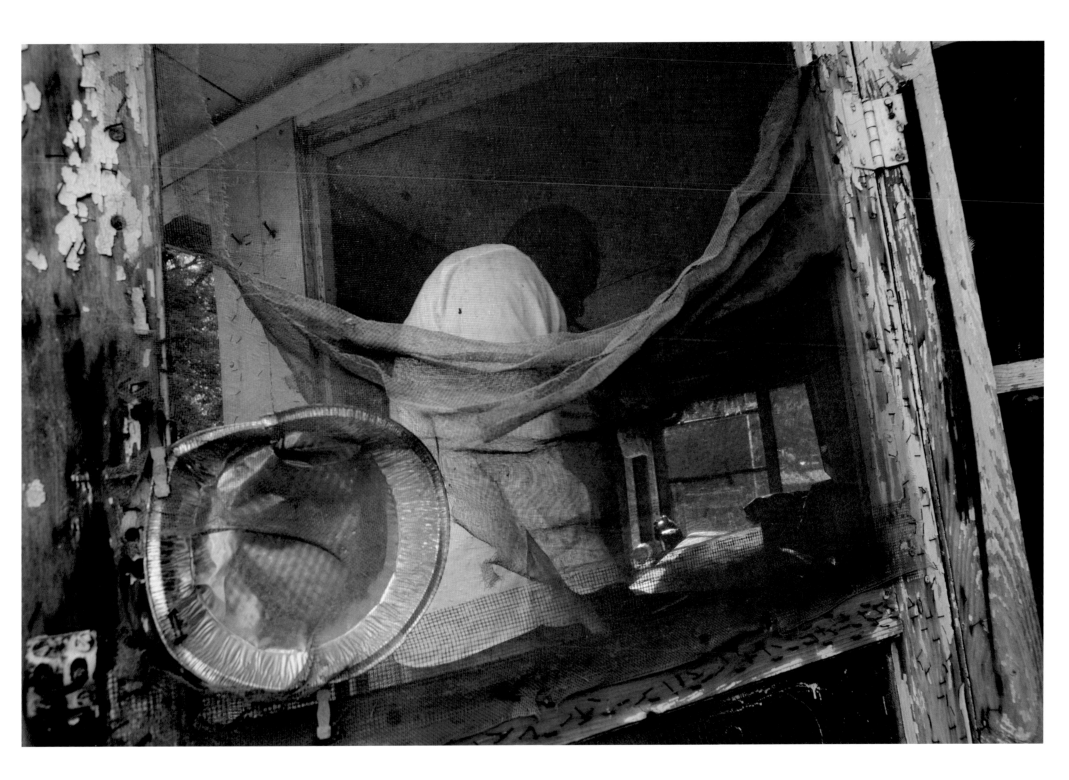

I have my father's bushy eyebrows, a beard that's going gray, a bald head,

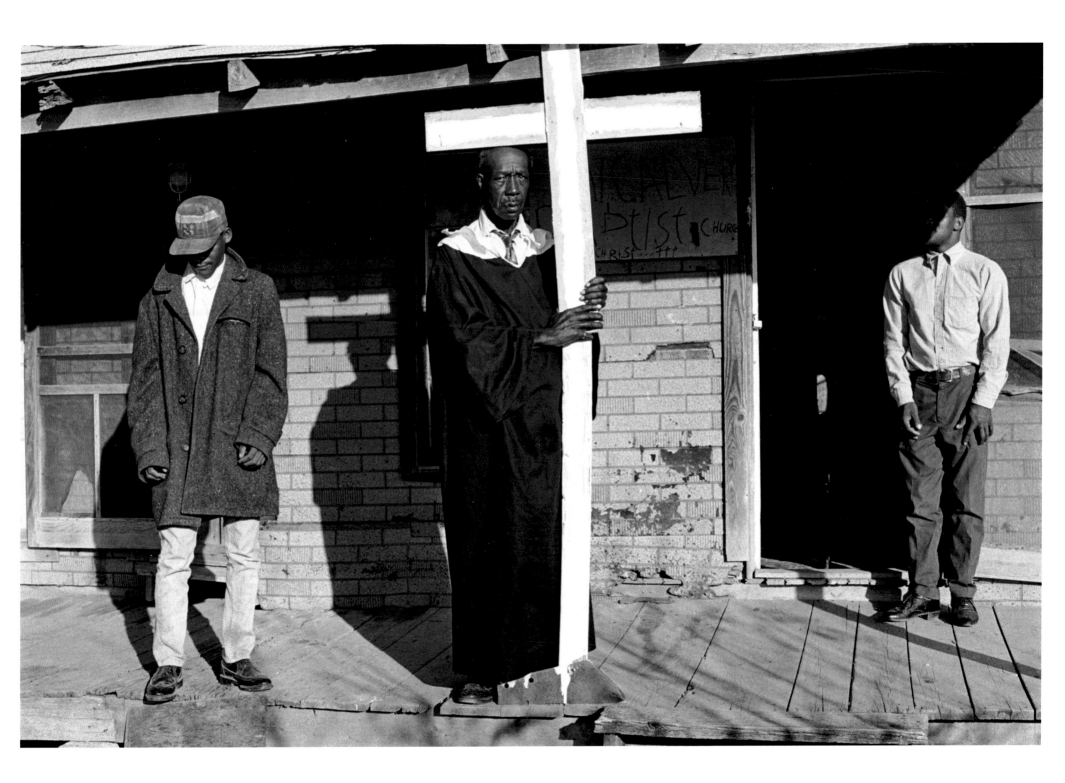

and a face that hasn't gotten fatter as the years have passed,

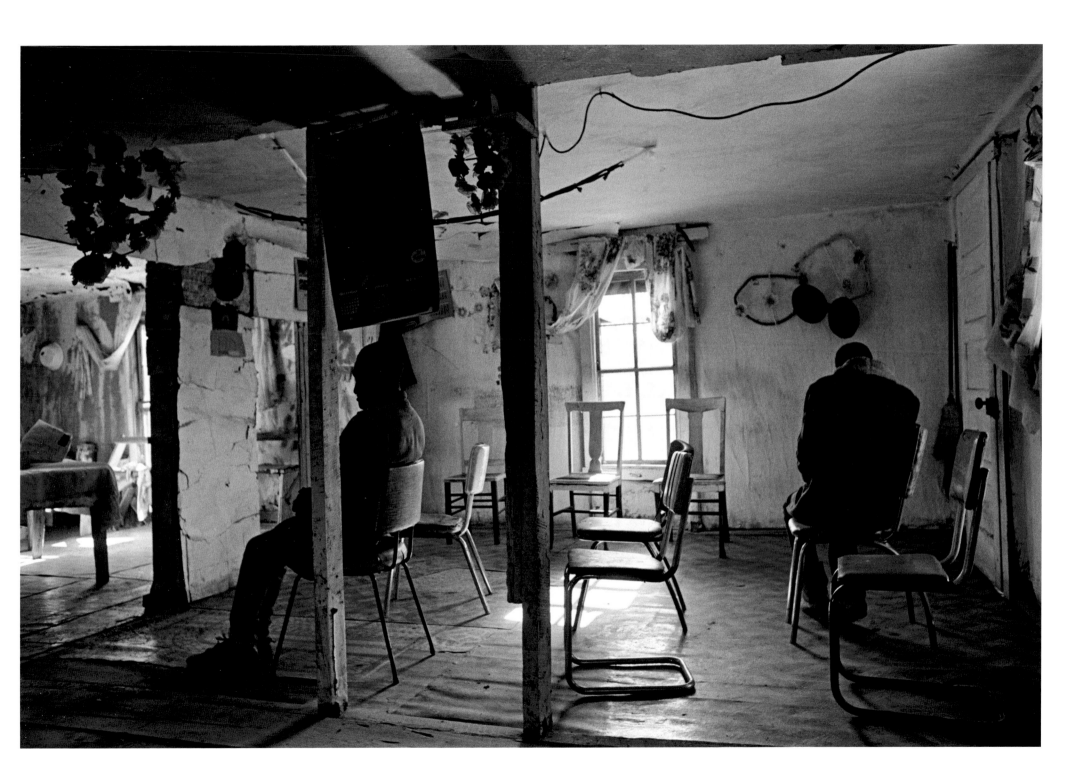

but is less fleshy and slightly hollowed out.

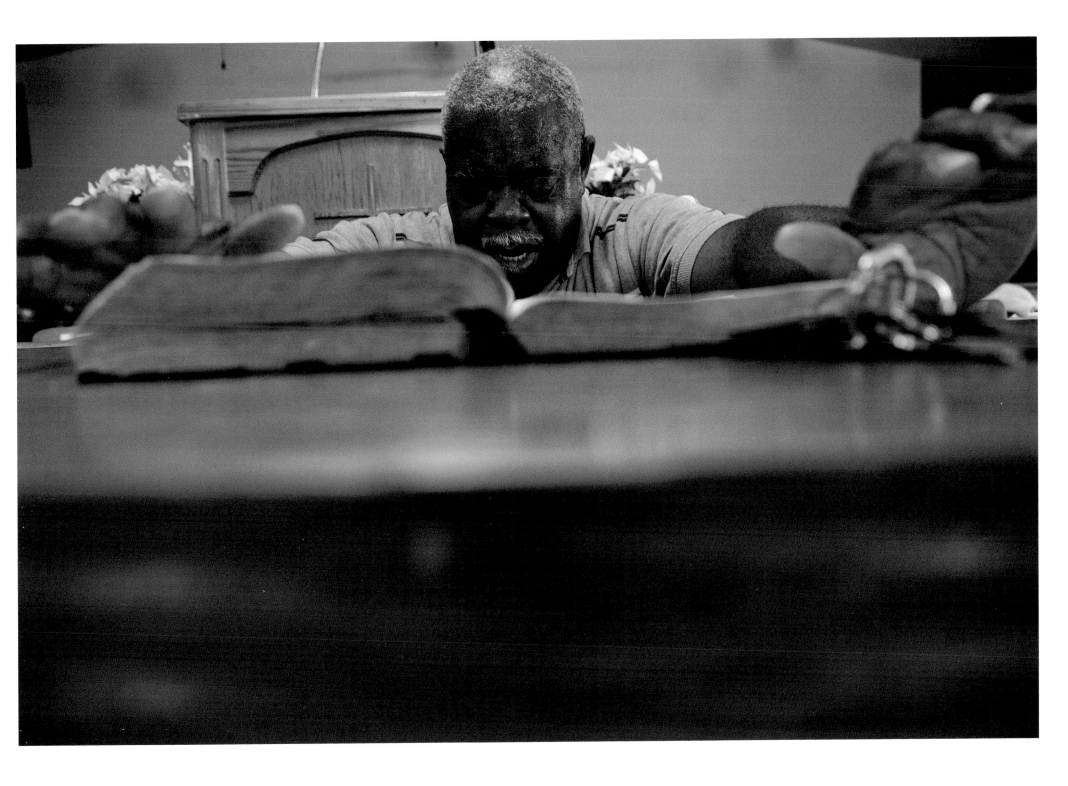

I peer outside when I hear a car start up, then back at the mirror,

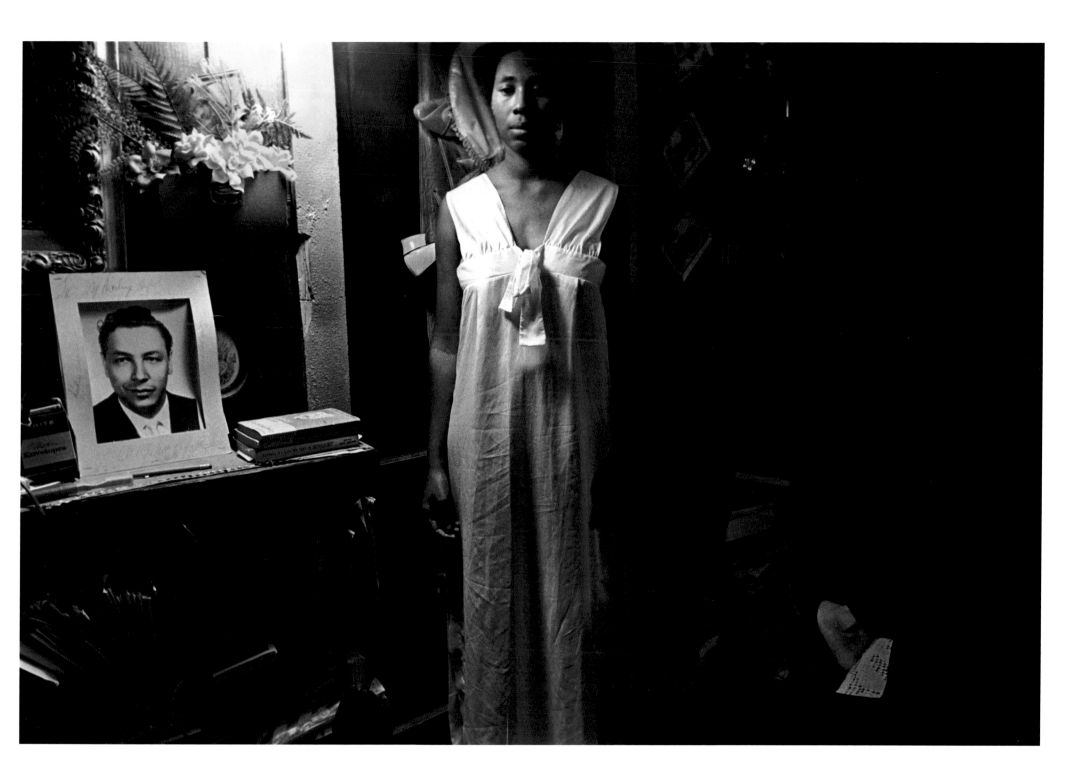

and I can't help thinking about Porter Lee and Mr. Will,

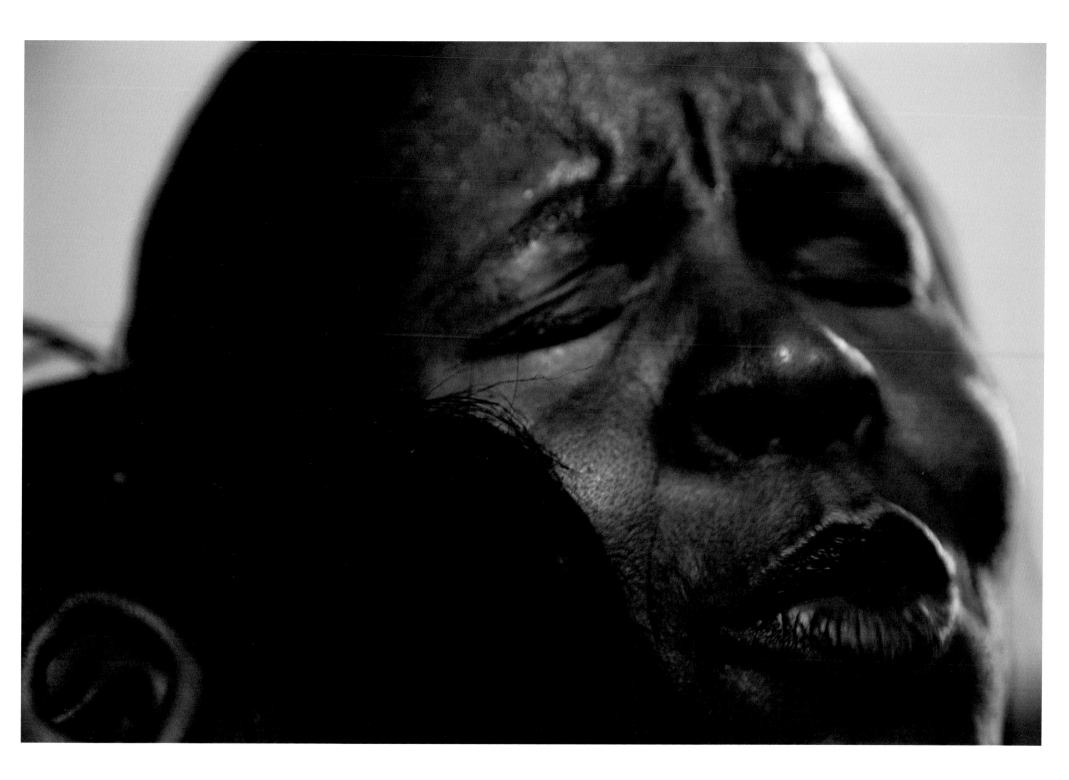

about my first wife dying,

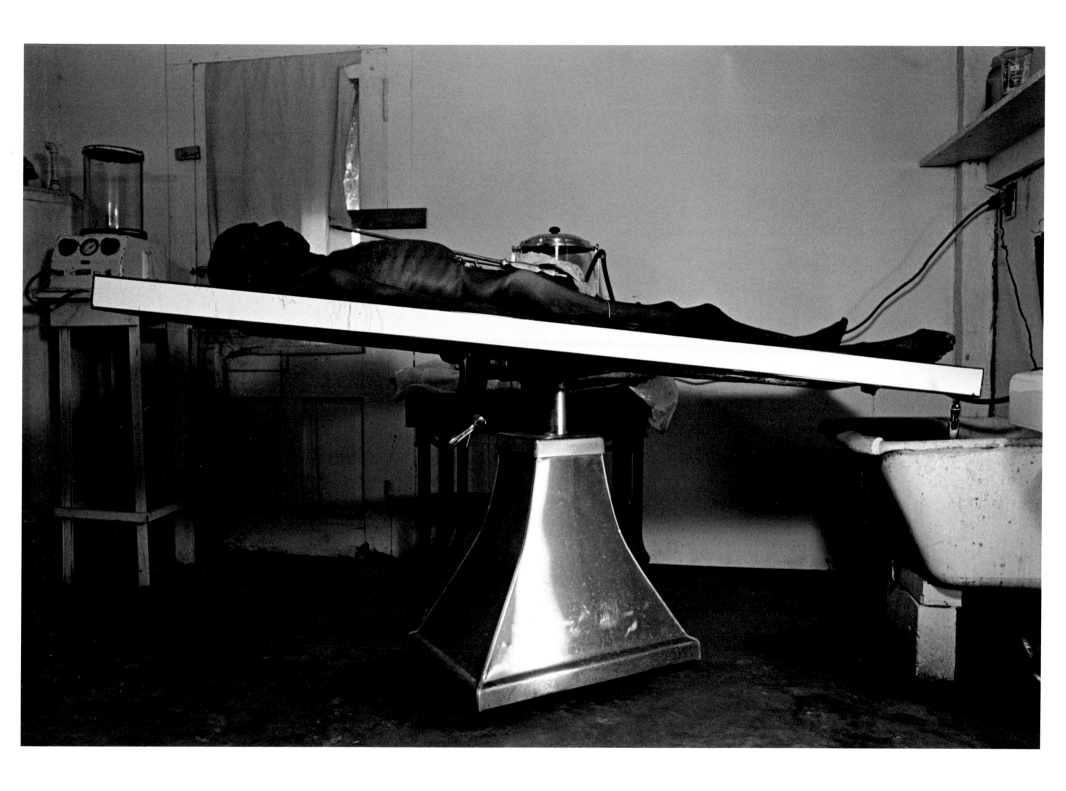

about softly touching Janine,

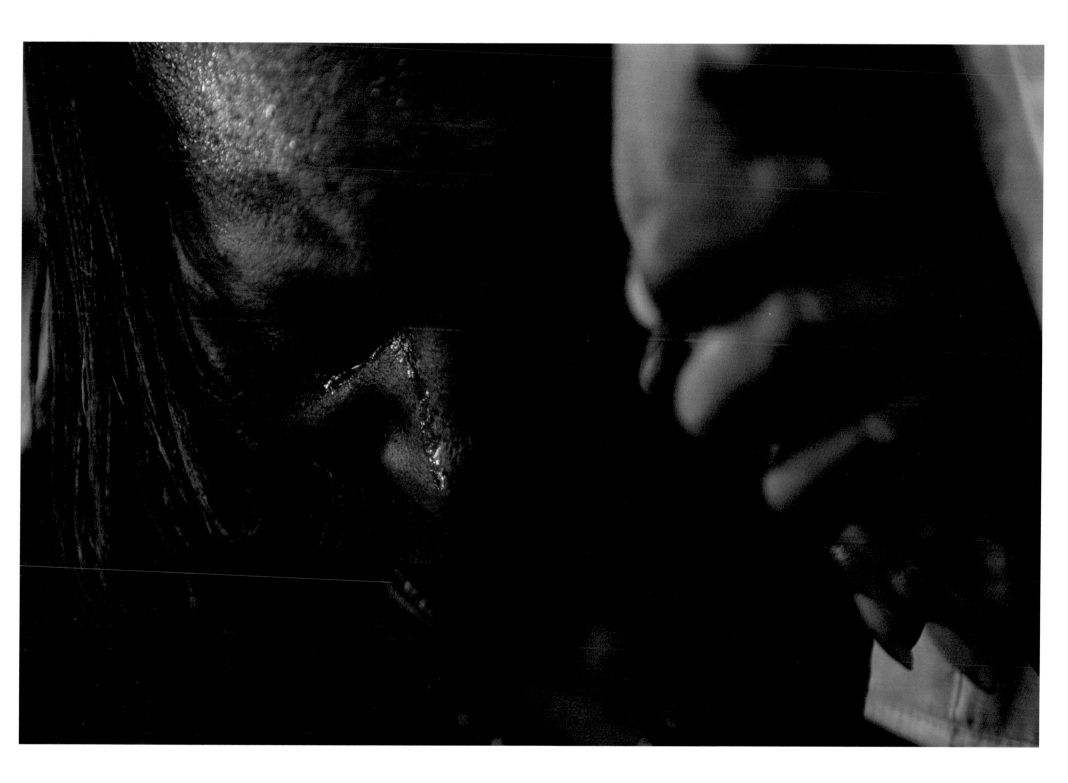

about life and death

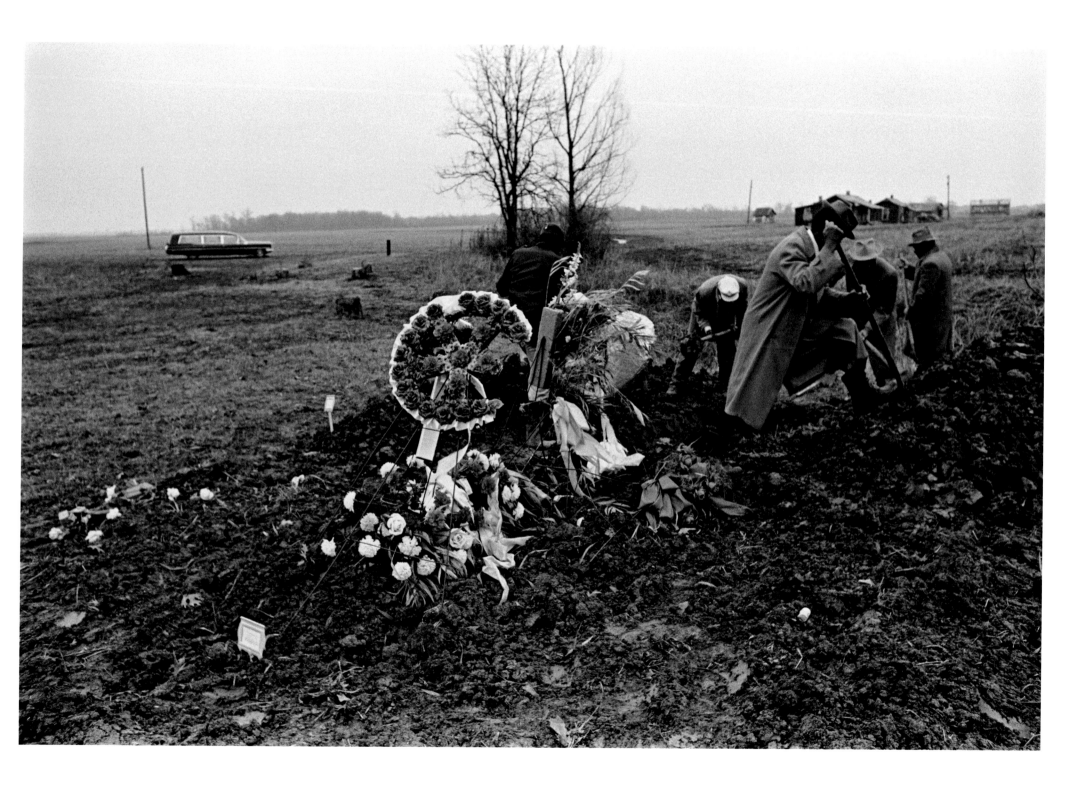

and how little time there is.

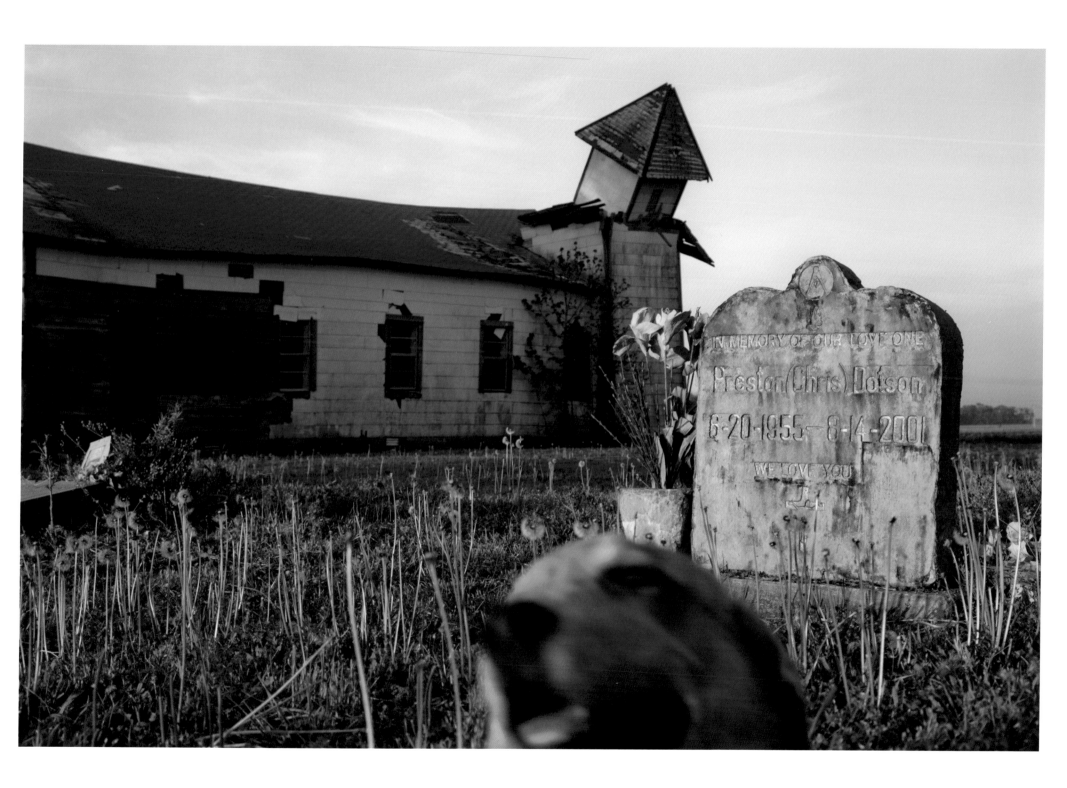

IN MEMORY OF OUR LOVE ONE
Preston(Chris) Dotson
6-20-1955 — 8-14-2001
WE LOVE YOU

Postscript

You cross over the Mississippi into Arkansas, pass a few miles of strip malls, truck stops, and motels and the landscape comes to look like an abstract painting, with the wide, flat fields and the sky pressed together. There's a migrant worker camp north of the interstate peppered with bullet holes, tractors in the distance throwing off dust, farmhouses here and there, but no people that you can see. It's August and nothing much forces people indoors like the heat.

You drive away from Marianna, with its statue of General Robert E. Lee and its dying downtown, and come to a cotton field where sharecroppers' shacks used to stand, four or five of them in a row, up on concrete blocks. They had corrugated tin roofs that would lift and rattle in the wind and cracks in the windows that, when it was sunny, threw off dots of light.

But because it's growing too dark to take pictures, you sit there. In the sweltering heat and out of sight of the road you drift a little, see things: two little girls, like stick figures, chasing after each other into the shadows, then lurching back into sight; the row of sharecropper shacks being cleared by fire; the storekeeper in Wynne aiming his gun. And as happens whenever you return to the delta, the space between things that came to pass long years ago and the way it is now begins to collapse.

# Photographs

In memory of Jerry Berndt

My deepest thanks to the people of the Arkansas Delta, whose lives inspired this work; to Janine Altongy for her patience and caring; to Sam Richards for his thoughtful assistance with the layout and design; to Harry Mattison for his selfless critique; to Les Clark for his companionship on the road; to Suzanne Salinetti, Sue Medlicott, Shamus Clisset, Tyko Lewis, and Tom Hurley for their professionalism and skill; to the editors of National Geographic Magazine for the assignment that brought me back to the delta; to those whose support of our fundraising effort made the production of this book possible.

Copyright © 2014 by MANY VOICES PRESS
Photographs and texts © 2014 by Eugene Richards
ISBN 978-0-991-21890-5

Distributed by
ARTBOOK | D.A.P.
155 6th Avenue, 2nd Floor
New York, NY 10013
artbook.com

All rights reserved. No part of this publication may be reproduced in any form or by any means without the written permission of MANY VOICES PRESS.

MANY VOICES is a tax-exempt 501(c)(3), nonprofit organization, founded in 1999, with the intent of producing books and films on contemporary social issues.
WWW.MANYVOICESINC.ORG

Design: Eugene Richards
Printed by The Studley Press, Dalton, MA
First Edition